Front cover: catalogue 21 'Two
Dancers in their Dressing Room'

Back cover: catalogue 10 'Woman
Putting on her Gloves'

CONTENTS

LENDERS

The Archdale Collection (Birmingham Museums and Art Gallery)

The Trustees of the British Museum, London

The Burrell Collection, Glasgow Museums and Art Galleries

The Syndics of the Fitzwilliam Museum, Cambridge

Josefowitz Collection

The Provost & Fellows of King's College, Cambridge (Keynes Collection)

Leicestershire Museums and Art Galleries

The Trustees of the National Gallery, London

The National Gallery of Ireland, Dublin

National Galleries of Scotland, Edinburgh

The Trustees of the National Museums and Galleries on Merseyside (Walker Art Gallery)

The National Museum of Wales, Cardiff

Musée Picasso, Paris

Private Collection

The Board of Trustees of the Victoria & Albert Museum, London

Walsall Leisure Services Department, Arts and Cultural Services Division from the Garman-Ryan Collection

PREFACE

Edgar Degas is widely accepted today as one of the greatest artists, as well as one of the best-loved. It is easy to forget that in his own time his work was controversial, and most particularly on account of the choice and treatment of his subjects. The superb quality of his technique and the immediate impact of his images have tended to obscure the issues raised by his subject matter.

The major exhibition of Degas' work which took place last year was not shown in this country. It created considerable interest among historians and lovers of his work in Britain. Tate Gallery Liverpool has undertaken the current exhibition in response to this interest. It also takes its place as one of a series of three devoted to artists whose interests have overlapped and whose working lives have spanned the last century: Edgar Degas, Walter Richard Sickert and Francis Bacon.

We are grateful to Richard Kendall for accepting the invitation to research and select an exhibition based on the Tate's holdings. The theme he has chosen to elaborate – Degas Images of Women – is undoubtedly of central importance to an understanding of Degas' work, and although a considerable literature on the subject already exists there has never been an exhibition based on this theme.

The selection has been made within various constraints. It does not attempt to treat Degas' early work, and largely comprises of works from within the British Isles. Much of Degas' work is fragile and easily damaged by travel. Last year's major exhibition has rightly exhausted the generosity of a number of lenders for some years. The Tate's own *Little Dancer Aged Fourteen* is now so fragile that it cannot be moved, though other bronzes and paintings from the Collection are shown here.

However, we have been exceptionally fortunate in the goodwill shown the Gallery by many lenders, and in particular by the Trustees of the National Gallery and by the Burrell Collection, Glasgow Museums and Art Galleries. The National Gallery has agreed to lend three works normally on permanent display in London, including one of Degas' most important works, (and a relatively recent acquisition), the portrait, *Hélène Rouart in her Father's Study*. The Burrell Collection has lent six works – an unprecedentedly large loan to a single show – including a number of magnificent and delicate pastels. We are most grateful to these and the other museums and galleries who have responded positively, as well as to the private lenders who have shown their public spirit by making available to the show works from their collections. Among the works on show there are several which have been rarely exhibited. It is these lenders who we must thank for making the exhibition possible.

Forty-six works constitute a small exhibition in these days of massive 'block-buster' shows, but if their quality demands attention, as it does here, they should be more than enough to satisfy us. In addition to the sheer quality of many of these works, we are offered a stimulating thematic analysis by Richard Kendall and his co-authors of the catalogue, Anthea Callen and Dillian Gordon. They must be congratulated on their contribution to our knowledge of Degas and the art of his time. The conservation staff of the Tate and the lending galleries deserve recognition for their enthusiasm in making Degas' works safe for travel and so available for viewing equally by scholars and a new public.

Nicholas Serota
Director
Tate Gallery

Richard Francis
Curator
Tate Gallery Liverpool

DEGAS' DISCRIMINATING GAZE

Richard Kendall

More than three-quarters of the total number of works of art produced by Edgar Degas are representations of women[1]. Degas had a long and productive working life (he died in 1917 at the age of 83) and used an exceptionally wide variety of techniques, but from the beginning of his career to the end, his art was dominated by images of the female form. Some of his earliest drawings were pencil studies of his sisters and aunts, while his first exhibited paintings were predominantly portraits of female friends, relatives and performers. During his association with Impressionism, Degas' name became identified with such subjects as the ballet-dancer, the laundress, the milliner and the cabaret singer, and he always affected a disdain for the landscape-painting of his colleagues. Many of Degas' most remarkable technical experiments, such as those in etching, monotype and photography, were principally based on female subject-matter, while there are some media, such as sculpture, in which male figures are effectively absent. His interest in portraiture never left him, but again the studies of women outnumber those of men by more than two to one. In later life Degas' preoccupation with images of women intensified; with the exception of some jockey pictures and a few portraits, his last two decades were almost entirely devoted to the two subjects which had dominated his career, the female dancer and the female nude.

Given the nature of the artists's obsession, it is surprising to discover that this is the first exhibition to explore the subject of Degas' depiction of women. A number of publications, such as those on Degas' ballet-dancers and nudes, have concentrated on specific and important aspects of his female imagery, and other studies have examined such imagery within the context of his sculpture, print-making, portraiture and modern-life subjects[2]. Amongst the great blossoming of Degas scholarship in recent years, a series of papers and articles have tackled isolated themes within the artist's broader obsession and we now have detailed studies of Degas' alleged misogyny, his images of maternity, his laundress pictures, his brothel scenes and his possible links with early Feminist sympathisers[3]. The awesome range and quantity of Degas' representations of women has, perhaps, discouraged the broader view and there has been an understandable tendency to focus on defined groups of pictures or limited historical phases. While the selection of works in *Degas Images of Women* does not presume to correct this imbalance, it does offer an opportunity to consider the entire range of Degas' female imagery, from virtually every historical period, every major subject area and every scale and technique used by the artist.

Degas was not, of course, alone in his preoccupation. In a society where the 'Woman Issue' formed an increasingly conspicuous element in political, ethical and economic debate, many of Degas' contemporaries (both male and female) devoted at least part of their energies to the depiction of women at all levels of the social system. Prominent amongst these were the novelists, several of whom were known personally to Degas, whose explorations of female behaviour and psychology were often based on subjects close to Degas' art. Flaubert's studies of middle-class heroines in *Madame Bovary* and *Sentimental Education* dealt with precisely the kind of women (the wives of a doctor and a business-man) that Degas is known to have painted, while the writings of Zola and others offer even closer parallels. Zola's novel *Térèse Raquin* (on which Degas probably based a painting) is the story of a shop-girl, his *Nana* is a prostitute and Gervaise, the heroine of *L'Assom-*

moir, worked as a laundress. The Goncourt brothers produced an account of a brothel (*La Fille Elisa*, also the subject of drawings by Degas), an artist's model (*Manette Salomon*) and a house-maid (*Germinie Lacerteux*), while other writers from Degas' immediate circle, such as Halévy and de Maupassant, published studies of dancers, prostitutes and female sexuality[4]. In the visual arts, several artists associated with Impressionism, such as Manet, Renoir, Morisot, Cézanne and Pissarro, shared to some extent in Degas' interest in female imagery. Amongst more traditional or established painters, again largely known to Degas himself, the subject was identified with Tissot, Boldini, Henner and Béraud. For all these artists, however, the subject was only one amongst a number of themes or the preoccupation of a limited historical period. The only individual to approach Degas' obsessional, life-long relationship with the female image was, paradoxically, a woman; the female painter much depicted by Degas himself, Mary Cassatt.

An examination of the full extent of Degas' subject-matter indicates that he was both more deliberate and more systematic in his depiction of women than has previously been supposed. There is something almost encyclopaedic in the range of his themes, as if the artists, following the practice of his novelist contemporaries and the scientists they claimed to admire, was collecting, classifying and ultimately hoping to define the object of his attentions. Several recent studies have explored Degas' known interest in scientific and technical matters, and the artist's own notebooks show some evidence of a methodical approach towards his subject-matter[5]. Degas gathered his imagery from the highest and lowest strata of society and from every corner of his urban environment; occupations, trades and leisure-pursuits were documented, physical types from the most to the least elegant were recorded and the whole gamut of ages, from the child to the grandmother, was encompassed. Some of Degas' pictures explored the moods and the physical indispositions of his female subjects, others their language of gesture, deportment and fashionable display. Rigorous to the end, Degas passed from the public arena of the street and the theatre to the private world of the dressing-room. In literally hundreds of drawings, pastels and sculptures he followed his models through the rituals of washing, drying and preening themselves, while some individual actions, such as brushing the hair, became the subject of separate groups of studies and variations.

While it can be argued that Degas covered a greater range of female subject-matter than any other artist before or since his day, it can also be shown that he approached this subject-matter in a more discriminating, calculated way than has previously been realised. The bewildering variety of his technical experiments and visual innovations are not scattered randomly throughout his female imagery, but are directed according to the nature of the subject depicted. At an immediate level, Degas only made explicit images of the brothel in one medium, the monotype; conversely, the monotype was never used for one of the favourite subjects of his pastels and oils, the portrait of the middle-class woman. Not only is Degas' imagery related to the chosen medium, but also to the artist's relationship with his subject. Many of Degas' compositional structures, choices of scale and, above all, his implicit vantage points can be seen as visual expressions of his attitude to the women depicted. Certain pictorial devices are used to suggest familiarity, distance or temerity, while others are confined to specific categories of female subject-matter. Whether these strategies were used consciously or otherwise, an analysis of Degas' visual language suggests that he based the clearest distinctions in his work on the class, the status and the social identity of the women depicted.

Degas came from a privileged background and thoughout his life made portraits of men and women from his own social class. The majority of his pictures and sculptures, however, were based on the working-class women of Paris, whether they were the entertainers at the cabaret and the ballet or the laundresses, shop-girls and professional

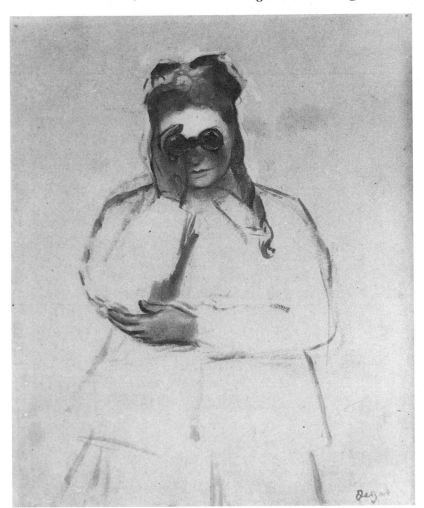

1. Degas, 'Woman with Field Glasses', c.1870. British Museum.

models with whom he came into daily contact. Just as his social encounters with different groups of people would have been expressed in varied rituals of behaviour and speech, so Degas' artistic responses were adjusted to the class of the women he depicted. Such distinctions might be evident in his choice of medium, his preference for certain poses and his interest, or lack of interest, in questions of clothing, gesture and personality. However, it is arguable that one of the most significant (and least studied) expressions of Degas' social differentiation is his *visual* relationship to the individual portrayed. When Degas selected his view-point, moved close to a figure or away from it, or when he chose to emphasise or suppress the subject's gaze, he modified his attitude (both literally and metaphorically) according to the status of his subject.

On a number of occasions, Degas himself drew attention to the importance of the act of vision in his art. In claiming that 'one sees as one wishes to see. It's false; and it is that falsity that constitutes art', Degas emphasised the volitional nature of both the seeing and art-making processes, while his remark that 'drawing isn't a matter of what you see, it's a question of what you can make other people see' stressed the significance of the viewer's response to his imagery[6]. Degas has rightly become celebrated for the visual inventiveness of his pictures, and his audacious view-points, asymmetrical compositions and differential use of focus are amongst the most distinctive features of his art. In several groups of paintings, pastels and prints (many of which depict women), Degas also made explicit reference to the visual process; he shows his female friends staring into mirrors or gazing fixedly at works of art (cat 9); he describes the prostitute's inquiring glance and her customer's confused response (cat 18); and he depicts the visitor to the race-track or theatre peering through binoculars or opera-glasses (fig 1). While some of these examples may be seen as formal structures within a pictorial narrative, or merely as social documentation, many of them have other significances. In the first place, Degas seems to insist

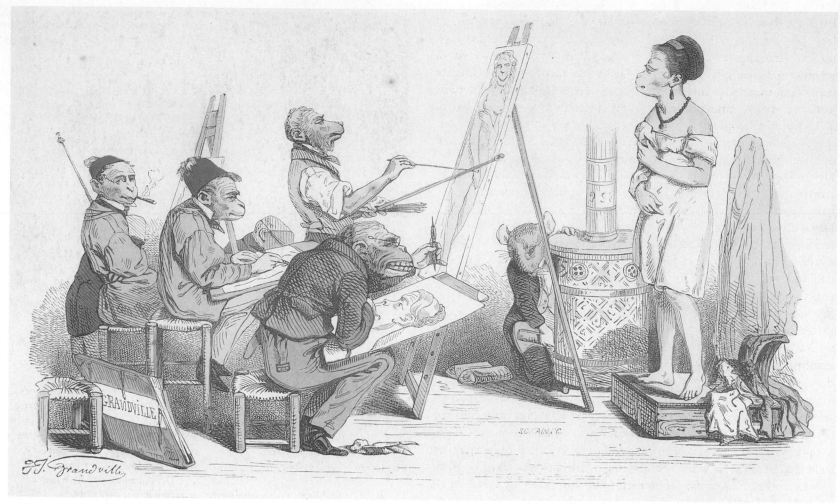

2. Grandville, 'Académie de Peinture'.

that the act of looking can be charged with meaning, whether it be concerned with vanity, commerce or sexuality. More particularly, Degas emphasises the *diversity* of our ways of seeing, as he differentiates between the act of scrutiny and the momentary glimpse, between the impudent stare and the lingering gaze, between the look of condescension and the look of respect.

Degas' most conventional 'acts of looking' were, in general, reserved for his most conventional subjects. Again, the analogy with social behaviour seems appropriate; in meeting with people of his own class, Degas maintained the outward forms of dress and polite ritual that tradition demanded. Any departure from these norms would have been regarded as disrespectful or even threatening, and it should be no surprise to find the artist extending this assumption into his visual imagery. The most orthodox relationship between the painter and his subject is shown in the less-than-serious illustration by Grandville (fig 2). Here the monkey-artists are arranged in the same horizontal plane as their model, looking directly at her and depicting her from frontal or partial profile view-points. As a young artist, Degas was schooled in these conventions, and many of his early portraits and self-portraits show the full-face, symmetrical position and the steadily returned gaze of the sitter (cat 1). If Grandville's apes are replaced by their human counterparts, such a view-point can also be seen as one of relative equality between artist and model; to 'look someone in the eyes' is to establish a parity of glances and an equivalence of status. The frontal, horizontal view of the subject and the exchange of eye-contact are characteristic of many of Degas' pictures of himself, his family and his social equals. While such an approach might be expected in the artist's youth, it is significant that Degas continued to use such conservative visual strategies in portraits of his female peers until the last years of his career. Despite its richness of personal allusion and great visual power, the painting 'Hélène Rouart in her father's study' (cat 6) (which is a study of the daughter of Degas' close friend and amongst the last

formal portraits he painted) is essentially a picture in the grand manner[7].

Grandville's picture of the artist's studio also demonstrates another fundamental relationship between painter and model, that of proximity. The view-point of the 'artist' in the foreground is twice as close to the model as that of his rather suave colleague at the extreme left, and he appears to be straining forward to concentrate even more closely on some detail of her head. Though Grandville's image is not entirely consistent, there is a self-evident tendency for an artist to advance toward the subject if emphasis is to be placed on the face and to retreat from it when the body or the background are a principle concern. A finished painting usually reciprocates this relationship, suggesting intimacy in the case of a head-and-shoulders portrait and relative distance (in both the physical and the psychological sense) in a full-figure or group study. Degas' work illustrates this principle very fully. As we might expect, his portraits showing an individual's face at close quarters are associated with his friends and family, especially when eye-contact is established. Such a format is never used for the working women who abound in the rest of his work, most of whom are shown at a distance or separated from us by a pictorial device such as a table, door-frame or high viewing angle[8]. Proximity suggests familiarity, as well as an interest in the individual portrayed. A portrait like that of 'Elena Carafa' (cat 5), which shows Degas' cousin, is sustained by her quizzical look and the subtle indications of her personality, while the wearers of 'The Red Ballet Skirts' (cat 22) are remoter from us in every sense, their bodies richly expressive but their faces vacant.

The most conspicuous of all Degas' visual devices is his choice of viewing level. Unlike Granville's monkeys, Degas positioned himself for a large number of his drawings and paintings either above or below the horizontal, at times choosing alarmingly high (fig 3) or low (cat 16) vantage-points. In a passage from one of his note-books, the artist even wrote down his strategy; 'After having done portraits seen from above,

I will do some seen from below – sitting very close to a woman and looking up at her …Studio plans; set up tiers all round the room to get used to drawing things from above and below'[9]. It is not known whether Degas modified his studio as he intended, but he evidently used high vantage-points such as theatre boxes and stage structures (cat 17) and sometimes placed his subject-matter at floor level (cat 39 & 40). Many of his pictures include elevated views of table-tops, floor spaces and the tops of heads, shoulders and limbs, and a substantial number presuppose a viewer considerably above normal eye-level. Degas' departure from 'the official way of seeing' was noted by contemporary critics, but its implications for the significance of his pictures have never been fully explored[10]. In opting for a raised vantage-point, Degas created pictures of extraordinary originality and immediacy, but he also placed himself outside the conventional routines of human contact. Situated above, but often quite close to, his subjects, the artist could observe without participating, viewing his subjects like a concealed observer or a 'fly on the wall'. Though not necessarily sinister, this view-point challenges the way in which human beings normally present themselves to each other, and suggests the breaking of social as well as visual conventions. A study like 'Nude in a Tub' (fig 3) is an extreme case of Degas' visual licence, but many of his pictures of ballet-dancers, cabaret singers, prostitutes and nudes involve less elevated view-points with similarly challenging implications. By looking down on a woman in her tub or up at the legs and torso of an acrobat (cat 16) the artist was, in effect, taking liberties with both artistic and social propriety. Degas himself implicitly accepted this view by only using such angles of vision when representing working-class subjects. With few exceptions, his studies of women of his own class are based on an equitable and level mutual confrontation, while plunging perspectives, bird's-eye views and intrusive lines of vision were reserved by the artist for those subjects which were (again literally and metaphorically) beneath him.

As an artist, Degas was restlessly innovative and rarely dogmatic. Any attempt to generalise about his practice and his imagery is likely to run aground on a series of exceptions or an uncharacteristic work. The exceptions themselves are often instructive, and may be as significant in their aberrance as others are in their conformity. It appears, for example, that 'The Theatre Box' (cat 12) follows some of the visual conventions of Degas' more mundane subject-matter while also representing women of an elevated class, but the fact that the scene is set in a theatre, where social groups and manners notoriously mixed, may have given the picture its rationale. Indeed, Degas' relative adherence to social demarcations, in a world where many of his contemporaries bemoaned their disappearance, is in itself instructive[11]. Despite the exceptions, however, there are pronounced patterns and tendencies within the wide range of Degas' images of women which have been too little explored. The great diversity of his art conceals attitudes, assumptions and habits of thought which are often inextricably linked with what the artist himself referred to as his 'ways of seeing'; the importance of these procedures is hinted at in Paul Valéry's claim that 'What Degas called a 'way of seeing' must…bear a wide enough interpretation to include way of being, power, knowledge and will'[12].

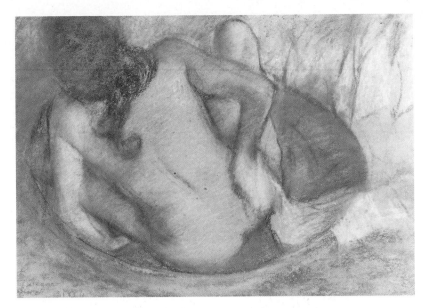

3. Degas, 'Nude in a Tub', 1884. Burrell Collection.

NOTES

Titles in italics are abbreviated references to the books and articles listed in *Works Frequently Cited in the Text* (page 71).
Numbers preceded by 'L' refer to pictures listed in *Lemoisne*.

1. This figure is based on an analysis of the standard catalogues of Degas' work; see *Janis, Lemoisne, Reed and Shapiro* and *Rewald*.
2. See *Browse, Shackleford, Thomson 1988, Rewald, Millard, Reed and Shapiro, Boggs 1962,* and *Lipton 1986.*
3. See *Broude 1977, Lipton, September 1980, Lipton, May 1980, Broude 1988* and Jean Sutherland Boggs, *Degas and Maternity,* to be published with the papers of the Paris *Colloque Degas,* 1988.
4. For a detailed discussion of some of Degas' connections with these texts see Theodore Reff 'the Artist and the Writer' in *Degas, the Artist's Mind,* New York, 1976.
5. See Douglas Druick and Peter Zegers, 'Scientific Realism 1873–1881' in *Boggs 1988,* pp 197–211; and *Kendall 1988.* The references in Degas' notebook appear in Notebook 30. Toru Arayashiki in *Pickvance 1988* mentions the influence on Degas of the sequence of female images in Sukenobu's *Views of One Hundred Women,* a copy of which Degas owned.
6. The first quotation comes from Daniel Halévy, *My Friend Degas,* London 1966, p 66; the second from Jean Adhémar and Francoise Cachin, *Degas; the Complete Etchings, Lithographs and Monotypes,* London, 1974, p 89.
7. Degas' tendency to use more informal poses for his portraits of men, especially when they were close friends, is noted in *Thomson 1988,* p 25.
8. The distinctive group of drawings and pastels of the heads and shoulders of dancers, produced towards the end of Degas' career (L 1272–1276 etc), usually imply a high view-point and avoid any eye-contact with the models.
9. Degas Notebook 30, pp 29 and 210. Translation from *Kendall 1987,* p 113.
10. See Charles Ephrussi, 'Exposition des Artistes Indépendants', *Gazette des Beaux Arts,* May 1880, p 487.
11. The blurring of class divisions is mentioned in many of the contemporary novels referred to in this essay. It is also extensively discussed in *Clark* and *Herbert.*
12. *Valéry* p 83.

ANATOMY AND PHYSIOGNOMY: DEGAS' LITTLE DANCER OF FOURTEEN YEARS

Dr Anthea Callen

1. Degas, 'Little Dancer of Fourteen Years, (wax statuette)' (c1880–1), Wax, silk, satin, ribbon, hair, 990 mm. Coll. Mr and Mrs Paul Mellon, Upperville, Virginia.

Here is a genuinely new endeavour, an attempt at realism in sculpture. A vulgar artist would have made a doll of this dancer; M Degas has made of it a strongly-flavoured work of *exact science* in a truly original form. (C E [Charles Ephrussi], 'Exposition des artistes indépendants', *Chronique des Arts* 18 April 1881, 126 (my italics)).

Criminal anthropology has, in a short time, reached people and regions that science could not have reached if we consider the latter in all its classical apparatus, and has given rise to so many discussions that if, for instance, Flaubert had written *Madame Bovary* in 1887 instead of 1857, Mr Homais and the curate of his town could not have discussed any other subject but Lombroso and his theories. (C Bernaldo de Quiros, *Modern Theories of Criminality*, trans. Alfonso de Salvio London, 1911, 17).[1]

In Degas' sculpture, 'Little Dancer of Fourteen Years' (c1880–1, fig 1), the artist made explicit use of images drawn from the sciences to make his figure instantly recognisable as a member of the *classes dangereuses*[2]. While scientific sources were a sign of modernity in art at this time, so the use of art to illustrate new scientific theories gave them a modern authority. Thus by 1880, the appearance of '... prints and engravings, all the graphic apparatus which was believed to be the legitimate monopoly of the natural sciences...' in new works on criminal anthropology, were the 'sure sign' of the ground-breaking novelty of their texts[3].

Focusing on Degas' 'Dancer', and the critical reactions to it, my brief here is to analyse how ideological meanings were constructed through this reflexive relationship between the discourses of science and art in this period. Degas' interest in physiognomy and anatomy can then be viewed not simply as a source of artistic inspiration in his search for a modern expressivity in his figures[4], but rather as evidence of a general trend towards submitting the human body – and the social body – to ever more rigorous forms of scientific classification. The language of science provided the artist with a new vocabluary of visual signs to modernise conventional pictorial codes and give art new representational powers[5]. These codes embodied new meanings, which formed a crucial component in the shifting languages of social classification.

Anatomy and Physiognomy

Physiognomy as a 'scientific' enterprise dates from the work of Lavater in the late eighteenth century[6] (fig 2). His premise was the correspondence of inner moral character to outer physical appearance. Along with Gall's science of phrenology, which sought to establish '...a philosophy of the mind based on the physiology of the brain...'[7], and pathognomy, '...the interpretation of changing emotions by facial or bodily expression...'[8], physiognomy dominated the popular imagination in Paris until the mid-nineteenth century and beyond. During this period of urban expansion, when new distinctions of class and gender were being negotiated in the modern city environment, the rapid visual classification of character types fulfilled an urgent social need. These theories of human types gained widespread currency, being absorbed via their pictorial and literary progeny into the discourse of

popular culture. Although discredited by scientists in the latter half of the century, the early work on human physiognomy and on skull types was nevertheless hailed as the foundation of modern anthropology[9].

Duval and Bical's *Anatomie des maîtres* (1890)[10], a history of anatomical drawing for artists, typically reinforced this view, placing the work of Lavater and the Dutch medical anatomist Petrus Camper[11] at the beginning of a line of development through Darwin to the modern anthropologists. These included the Darwinist anthropologists Caesar Lombroso (an Italian criminologist), Paul Broca and Arthur Bordier[12]. Many anatomists bridged the gap between science and art, and Mathias-Marie Duval (1844–1907) was a prime example. Himself a warm supporter of Darwin's theories, Duval was a medical anatomist and physiologist who held the influential post of Professor of Anatomy at the Ecole des Beaux-Arts from 1873 to 1899[13].

Adopting an overtly biologistic view in their introduction, Duval and Bical defined anthropology as the science of '…the human races, which it classifies, defines and describes on the basis of their *anatomical* characteristics'[14]. They noted that methods of racial classification based on skull measurements were first developed in the work Camper. In the 1870s these methods, refined and given a more rigorous scientific basis, were directed by Lombroso towards the classification of *social* types – in particular what he called 'the born criminal'[15]. Duval's teacher, the psychiatrist Morel, had published a treatise in the 1850s on *The Physical, Intellectual, and Moral Degeneration of the Human Species* which, for the first time, proposed a relation between criminality and degeneration. Morel linked his theory of degeneration – '…a kind of retrogressive natural selection…' – to the ideas developed by Lucas on the transmission of crime by heredity in his *Traité de l'hérédit naturelle* (1847)[16]. These theories were highly popular at the time Degas conceived his 'Dancer', and were explored in literature by Emile Zola. Naming the 'Dancer' after the infamous title-character from the recent Zola novel, one of Degas' critics explicitly identified the figure with prostitution and degeneration in the minds of the public: she was '…a little fifteen year-old Nana…'[17].

Camper had adopted an evolutionist model to argue racial difference based on cranial structure (fig 3). Like most anatomists, he used Greek Classical sculpture as the anatomical norm against which to measure his actual samples. Greek art was given a *literal* authority in anatomical texts, and was used uncritically to support scientific theories of evolution. Camper argued that the cranial structure characteristic of certain races differed markedly from the Classical norm. To demonstrate this, he developed his famous *facial angle*. Two lines were taken, '…one running almost horizontally from the earhole to the upper jaw (*la machoire supérieure*)… the other more or less vertical, running from the jut of the forehead to the projection of the upper incisor teeth'[18]. the angle formed by the intersection of these two lines was designated *l'angle facial de Camper*. According to Camper, the angle made by the second *characteristic* or *facial* line varied from 70° to 80° in the human species: Europeans 80°, yellows (as he called them) 75° and blacks 70°. Duval and Bical paraphrased his conclusions: '…all that rise above that [angle] express the rules of art, of imitation of the antique; and all that drop below the line fall into the resemblance of monkeys (orang-outang, 58°)[19].

By 1845 Camper's facial angle was being used to criticize artists whose ignorance of scientific anatomy resulted in 'unrealistic' depictions of blacks, who were commonly given '…boot-blacked caucasian heads…'[20]. Authenticity in the emergent realist style of figure painting was thus becoming contingent upon the adoption of scientific codes of representation. While Classical art (fig 4) had come to represent the summit of evolutionary progress, pictorial realism became a tool of science in the signification of lower evolutionary states, adding the visual authority of art to anatomical texts. Arguing

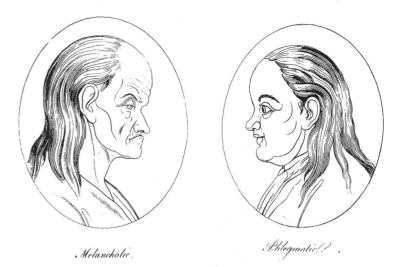

Melancholic. *Phlegmatic!?*

2. Johann Caspar Lavater, 'Melancholic and Phlegmatic Types', *Essay on Physiognomy*, 1789.

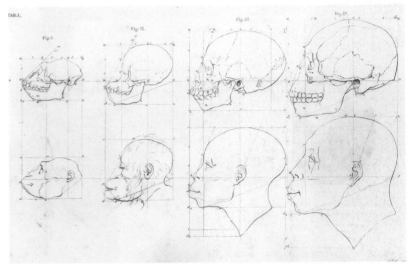

3. Petrus Camper, 'The Evolution of Man', *The Works…on the Connexion between the Science of Anatomy and the Arts of Drawing, Painting, and Statuary*, London, 1821, Tab I and II.

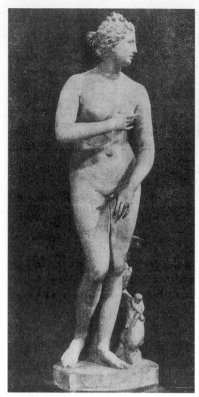

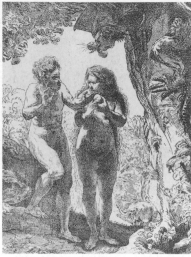

5. Rembrandt, 'Adam and Eve' (1638, etching), the frontispiece from Dr Galtier-Boissisière, *La Femme*, n.d., [1905].

4. 'Vénus de Médicis', from Dr Galtier-Boisière, *La Femme* n.d.,[1905], fig 11, 'The beautiful and the normal are identical' (*ibid.*, 15).

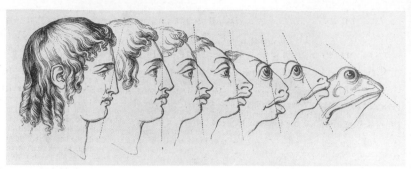

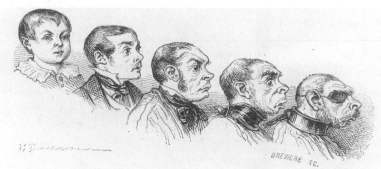

6. Grandville (Pseudonym), 'Man Descending towards the Brute' (1843), woodcut.

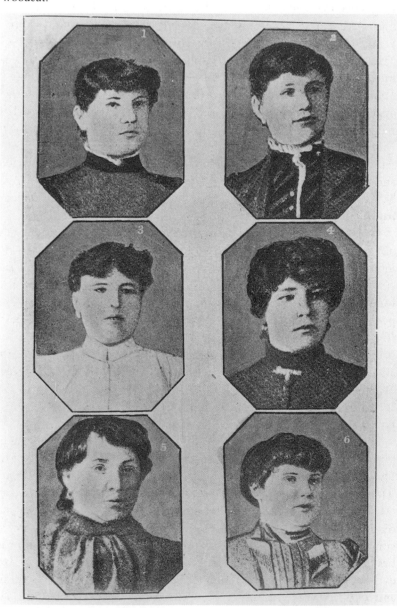

7. Photo, 'Russian Fallen Women', from Lombroso and Ferrero, *The Female Offender*, London, 1895, pl 11.

that modern woman was inferior to man and, further, in the process of degeneration, the Darwinist Galtier-Boissière, for example, illustrated Rembrandt's etching *Adam and Eve* (fig 5) as empirical evidence of the appearance of primitive woman[21]. Art, as a result of its use in such treatises, was taken to encode *scientific* signs of anatomical difference – whether racial, class or gender – which signified to the informed spectator a figure's relative evolutionary development. The pressure to construct visual signs of difference stemmed from the growing need of the male European bourgeoisie to establish for itself a separate and higher state of evolution, both biological and cultural, to help legitimise its postion as a ruling patriarchy at home and abroad. This need was frequently made explicit in anatomical treatises.

As knowledge of the work of anatomists and anthropologists spread, the 'degenerate' skull type with an acute facial angle, jutting jaw and prominent cheek bones became popularly associated with low social class, ignorance, and further, criminal bestiality. Typical of such popularisations is Grandville's 'Man descending towards the Brute' of 1843 (fig 6). Degas represented these atavistic traits of the criminal type in his 'Little Dancer'; in particular, the masculine characteristics, which Lombroso considered most marked in female sexual criminals, are visible in the head. In his descriptions of prostitutes, including one turned criminal and murderess, Lombroso emphasised the 'Strong jaw and cheek-bones...[the] alveolar prognathism [projecting tooth sockets]...', the '...immensely thick, black hair...receding forehead...and an exaggerated frontal angle, such as one notes in savages and monkeys; while the jaws and lip – indeed [the] whole face is essentially *virile*' (fig 7). Lombroso explained his theory:

The criminal being only a reversion to the primitive type of his species, the female criminal necessarily offers the two most salient characteristics of primordial women, namely, precocity and a minor degree of differentiation from the male – this lesser differentiation manifesting itself in stature, cranium, brain, and in muscular strength which she possesses to a degree so far in advance of the modern female ... for what we look for most in the female is *femininity*, and when we find the opposite in her we conclude as a rule that there

must be some anomaly. And in order to understand the significance and the atavistic origin of the anomaly we have only to remember that virility was one of the special features of savage woman.[22]

Crucial to Lombroso's argument was the notion that the cause of deviant or criminal sexuality in modern woman could be found in *genetic* deviance. Atavism in woman resulted in a loss not only of physiological but also of moral femininity: the two were conflated in his theory. A robust physique was considered degenerate in modern woman, and responsible for an assertive masculine virility. Whereas virility in man was the cultural norm, in woman it was a sign of deviance from a feminine sexual passivity. Biological evidence was marshalled by the evolutionists to give scientific credibility to bourgeois cultural norms of masculine and feminine sexual behaviour. Bourgeois codes of sexual deviance were thus legitimized in scientific discourse, and social problems, such as female sexual non-conformity and prostitution, could be blamed on woman's *biological* degeneration. It is within this discourse that Degas' 'Little Dancer' must be understood.

Degas' 'Little Dancer of Fourteen Years'

Degas had planned to have the 'Little Dancer' ready for the Fifth *Exposition de peinture* of 1880, and it was announced in the catalogue for that year[23]. Gustave Caillebotte, who had organised the show, expressed his irritation at Degas, who showed only the empty glass case in which he intended to house the 'Dancer'[24]. It did, however, whet the appetites of public and critics, arousing their curiosity in anticipation of the work's appearance. The hype continued in 1881, for when the show opened on 2 April the glass case was again empty; its appearance the previous year was recalled by at least two critics and, as Jules Claretie noted on 5 April: 'Up to now we have seen only the glass cage destined to receive and protect the statuette . . . we are lying in wait for his sculpture. And he is enough of a teaser not to send it'[25]. By 16 April, the 'Little Dancer' had finally appeared[26].

Contemporary images of the Paris Salon suggest that glass cases were not normally used even for small modern sculpture[27] (fig 8), thus the interest surrounding Degas' piece would have been all the greater. Glass cases were used for displaying certain Antique exhibits at the Louvre, as for example the etruscan sarcophagus drawn by Degas in c 1878, a possible prototype for the case designed by Degas for this statuette[28] (fig 9). While uncommon for modern sculpture, such cases would have been the norm for zoological and similar exhibits in a scientific context, an association evidently present in the minds of Degas and his critics. Significantly, Claretie's references to the case as a 'cage' and to the spectators as 'lying in wait' evoked connotations of savage beasts and of prey, even before the sculpture itself went on public view.

The critics' reactions confirmed the extent to which the languages of physiognomy and criminology had become integral to modern artistic discourse. Elie de Mont referred to the figure as a 'puny specimen'. Trianon, too associated Degas' careful study with science rather than an art; as an exhibit '. . . in a museum of zoology, anthropology, or physiology, fine: but in a museum of art, forget it!' Advising the artist to concentrate in future on the Darwinism of *aesthetic* selection – on the best and most beautiful individuals rather than the ugliest and least evolved – Trianon explicitly linked beauty with advanced evolution and ugliness with atavism[29]. The 'Comtesse Louise' took a similar view, reassuring her readers that the figure would be placed in the Musée Dupuytren. This institution, founded by a French surgeon of that name, is a museum of pathological anatomy formerly housed in the remains of the refectory of the Cordeliers at the École de Médecine[30]. Precocity, a characteristic stressed by Lombroso, was a feature of Degas' statuette remarked upon by the conservative critic Paul Mantz,

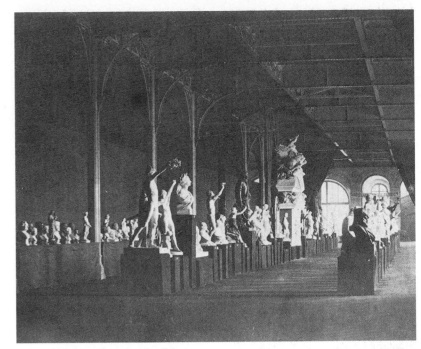

8. C Micheloz: photograph of the sculpture installation in the Palais de l'Industrie, Salon of 1866, Archives Nationales, Paris.

9. Degas, 'At the Louvre, Etruscan Sarcophagus' (c1878), pencil, 105 × 165 mm, Williamstown, Mass., Sterling and Francine Clark Art Institute.

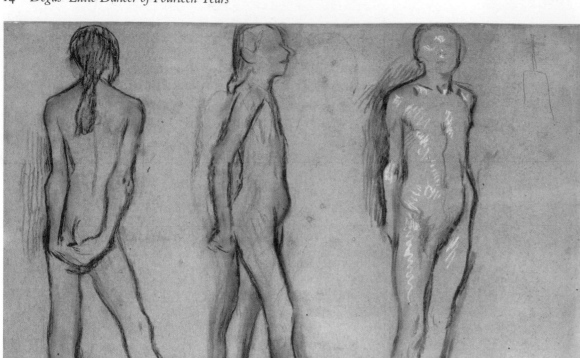

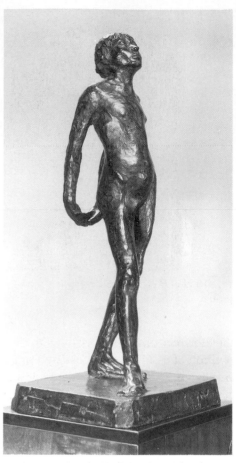

10. Degas, Studies [nude] for the 'Little Dancer of Fourteen Years' (c1878–80), charcoal heightened with white chalk, 480 × 630 mm. Private Collection.

11. Degas, Nude Study for the 'Little Dancer of Fourteen Years' (c1878–80), bronze, 718 mm. Edinburgh, National Gallery of Scotland.

who referred to her as a '...flower of precocious depravity...'[31].

That Degas was consciously exploring monkey and other animal physiognomies as scientific signifiers of low class Parisiennes at this period, is reinforced by the frequency with which such analogies were made by the reviewers. Claretie noted that '...the vicious muzzle of this little, barely pubescent girl, this little flower of the gutter, is unforgettable'[32]. Also using the word 'muzzle', and playing on the slang *rat* by which the Opéra dancers were known, Mantz emphasised the aptness of the dancer's features to her profession: '...with bestial effrontery she thrusts forward her face, or rather her little muzzle – and this word is completely correct because this poor girl is the beginnings of a rat'. De Mont also found that this '...opera rat takes after a monkey...'[33]. The visual evidence shows how Degas transformed his model, the Belgian dancer Marie Van Goethem[34], to give his sculpture an emphatically primitive cranium.

Between the preparatory drawings and the nude maquette (fig 10 and 11), a number of important alterations were made by Degas. Indeed, most of the studies do not show the atavistic profile of the finished sculpture (fig 12, cf. fig 1). Discussing the nude maquette modelled in red wax and later cast in bronze, McMullen notes that '...cracklike lines and an imprint still visible...reveal, for instance, that he tilted the head farther back...'[35]. This calculated shift in the angle of the girl's head realigned the ear to emphasise the horizontal of the elongated jaw-line and cropped hair. In a sheet of nude studies an earlier, less dramatic, form of the head is shown in the profile view, in the central drawing of the three (fig 10). Similarly, the angle and protrusion of the cheekbones was exaggerated in the bronze study to stress this horizontality, which is echoed in the horizontal formed by the elongated nose (fig 13).

In the process of transformation between drawings and finished statuette, the forehead was also modified; Degas lowered it, tilted it further back and flattened it. In the 'Little Dancer' the forehead all but disappears beneath the long fringe of hair. The highest point of the bronze study is in fact the top of the head just behind the forehead, whereas in the final sculpture the crown was made the highest point. A thick mat of horse hair extends the back of the skull outward in a dramatic bulge to counterbalance the elongated muzzle, '...the vulgarly upturned nose, the protruding mouth...'[36]. While in the bronze study the cranium is rounded, the hair on the 'Little Dancer' flattens the skull top, creating a line which reiterates and strengthens the facial horizontals. A comparison of the two profiles (figs 12 and 13) shows how Degas extended forward the whole 'muzzle' area of the face; the compact skull shape of the study was transformed into a long ellipsoid, accentuating the simian features. The resulting facial angle in the 'Dancer' is even more acute than that in the study: at little over 45° it is even narrower than Camper's 58° orang-outang. Seen from the front, too, the lop-sided skull shape displays Lombrosian cranial anomalies (fig 14). These changes made the 'Dancer's' head the focus of visual meaning; it signified precisely that unfeminine, atavistic precocity – literally a *forwardness* and want of modesty – described by anthropologists in respect of the born female criminal. Degas' 'Dancer' was 'terrible' because '...she is without thought...', mindless and therefore subhuman, ruled by instinct, not reason. Paul Mantz recognised '...the *instinctive* ugliness of a face on which all the vices imprint their detestable promises'[37].

It is no coincidence that in the same exhibition Degas complemented the female 'Dancer' with two pastels of male 'Physionomies de criminels' (figs 15 and 16). Indeed, Degas' delay in sending the statuette obliged the critics and public to focus their attention on these pastels, which prepared them for the eagerly awaited sculpture[38]. The pastel profiles were, according to Geffroy, '...taken in the dull light of the Criminal Court...'; the three men were identified by him as the assassins Abadie, Kirail and Knobloch. Although, as Mantz commented, these pastels '...would do nothing to enhance [Degas] reputation...',

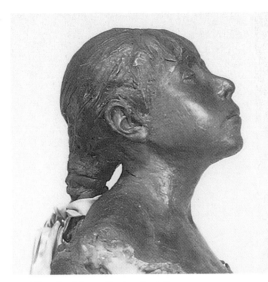

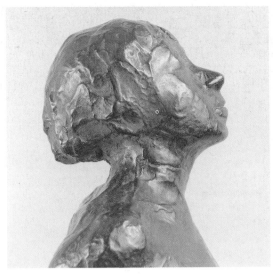

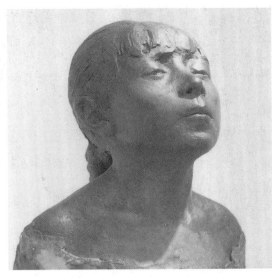

12. Detail of fig 1, the head, right profile.

13. Detail of fig 11, the head, right profile.

14. Detail of fig 1, the head, front view (full face).

they formed a discursive unity with the 'Dancer'. This eloquent juxta-position of exhibits was a common practice of Degas; here he used it to emphasise his physiognomic signposting of degeneracy in the Dancer[39]. Thus Gustave Geffroy linked the twinned exhibits in a single sentence, and his comments on the pastels reiterated those on the sculpture: 'Only a keen observer could render with such physiological sureness these animal foreheads and jaws, kindle these flickering glimmers in these dead eyes, paint this flesh on which are imprinted all the bruises, all the stains of vice'[40]. Criminality could thus be labelled and marginalized as a class- and even a gender-specific problem. Rather than confronting what was a social issue requiring social change, the identification of degeneration with individual heredity tended to encourage advocates of grandiose schemes for social engineering, like Malthusian selective breeding or Galton's eugenics[41].

Even now described as epitomising '...the ugly, the modern, the real...', Degas' 'Dancer' displayed to his contemporaries '...a strangely attractive, disturbing and unique Naturalism...'[42]. However, despite the fact that naturalism was a style, and Degas' physiognomic distortions consciously contrived, his combination of realist conventions with physiognomic and criminological signifiers attached to his work a 'scientific' objectivity, which suggested to the spectator an unmediated authenticity. As the critic Georges Rivière wrote of Degas' *Milliners*: '...there is no truth without ugliness, ugliness alone expresses reality'[43]. An art object laced with the guile of a Madame Tussaud waxwork, Degas' 'Dancer' was taken to constitute 'real life'[44].

The conflation of art and reality enabled critics to shift the responsibility for signification from the artist to the model. Thus the complex meanings which Degas inscribed in his sculpture were accepted as *actual* attributes of the hapless Marie Van Goethem. Henry Trianon, for example, was convinced that Degas had selected a model '...among the most odiously ugly; he makes it the standard of horror and bestiality'[45]. All the critics – then and since – refer to the sculpture as 'she', discussing 'her' imputed qualities as if the sculpture were a real person. Science and art thus worked hand in hand to conflate ugliness with vice, and to present the result as *reality*, as part of a 'natural' social order and not the ideological construction it in fact was.

Before the 'Dancer', the thrill for the bourgeois spectator lay in his terror on confronting the physiognomic likeness of the class from which he sought to differentiate himself. As Stalleybrass and White stated recently in a comparable context: '...the bourgeois spectator surveyed and classified his *own antithesis*...'[46]: his antithesis here being an *Other* distinguished by both gender and class. This *frisson* is evident in the reviews. The words 'horror' and 'terror' appear frequently, as did metaphors intended to evoke in the reader a horror akin to the specta-

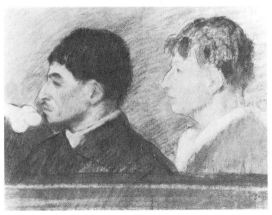

15. Degas, 'Physionomie de criminel' (1880–1?), pastel on paper, 640 × 760 mm. Present whereabouts unknown.

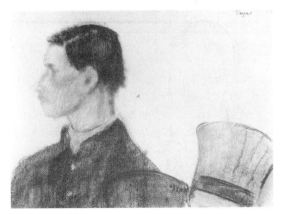

16. Degas, 'Physionomie de criminel' (1880–1?), pastel on paper, 480 × 650 mm. Present whereabouts unknown. Pastels of these titles were exhibited in 1881 at the sixth Impressionist exhibition.

tor's shock. De Mont likened the 'Dancer' to an 'expelled foetus' which, if smaller '...one would be tempted to pickle in a jar of alcohol'. He thereby conjured for the audience alarming associations between medical monstrosities and aborted infants, linking the sub-human or the evolutionarily deformed with the disturbing mysteries of normal female procreation. On a quieter but equally direct note Huysmans remarked: 'The bourgeois admitted to contemplate this wax creature remain stupefied for a moment and one hears fathers cry: "God forbid my daughter should become a dancer"'[47].

NOTES

1. De Quirós was discussing Caesar Lombroso's theory of the 'born criminal'; he could more aptly have given the date 1879, for in January that year *La Nature* – a popular science periodical read by Degas – published the most recent scientific findings on the subject. See Douglas W Druick and Peter Zegers, 'Le réalisme scientifique 1874–1881' in *Degas*, Paris, Éditions de la réunion des musées nationaux, 1988, 208–9, and see n 40, below.

2. The term was popularised by Louis Chevalier in *Labouring and Dangerous Classes in Paris* 1973, but, as Roger Magraw points out, his view of the 'dangerous classes' needs to be corrected by G Rudé, 'Cities and Popular Revolt' in J Bosher (ed), *French Government and Society 1500–1850*, 1973.

3. De Quirós, *op.cit.*, 32–33.

4. As suggested by Theodore Reff, *Degas, The Artist's Mind*, London, 1976, especially 217–220, hereafter referred to as Reff.

5. On Degas' scientific realism, see Douglas W Druick and Peter Zegers, *op.cit.*, 197–211.

6. Johann Caspar Lavater, *L'Art de connaître les hommes par la physionomie*, first published in Paris in 1806–9, and widely re-printed and popularised thereafter.

7. Franz Joseph Gall, *On the Origin of the Moral Qualities and Intellectual Faculties of Man, and the Connection of their Manifestations*, trans. Winslow Lewis, Boston, 1835, ii, 172, cited in Charles Colbert: '"Each Little Hillock hath a Tongue" – Phrenology and the Art of Hiram Powers', *The Art Bulletin*, June 1986, lxviii, no 2, 282.

8. Judith Wechsler, *A Human Comedy: Physiognomy and Caricature in 19th Century Paris*, London, 1982, 15, and see her outline history of this field (especially Introduction and ch 1).

9. De Quirós, *op.cit.*, 2; he describes this phenomenon, the development of psychiatry and the rise of statistical science, as the three motivating forces behind the growth of criminal anthropology out of the earlier sciences of physiology and phrenology. On the emergence of the petit bourgeoisie, see T J Clark, *The Painting of Modern Life: Paris in the Art of Manet and his Followers*, London, 1985.

10. Mathias-Marie Duval and Albert Bical, *L'Anatomie des maîtres*, Paris, 1890.

11. Petrus Camper, *Dissertation physique sur les différences réelles que présentent les traits du visage chez les hommes de différents pays et de différents ages . . .* first French trans, 1791. Like many anatomists, Camper cultivated painting and drawing as well as being a professor of anatomy, and he did all the illustrations for his own books. In addition to texts on anatomy, he published works on gesture and expression; see for example *Discours . . . sur le moyen de représenter . . . les diverses passions sur le visage . . .*, Utrecht, 1792 which, like the earlier work of Charles Lebrun, compares men and animals.

12. Caesar Lombroso, *The Criminal, in Relation to Anthropology, Jurisprudence, and Psychiatry*, 1876; Caesar Lombroso and William Ferrero, *The Female Offender*, London, 1895; Arthur Bordier, 'Etude anthropologique sur une série des cranes d'assassins', *Revue d'Anthropologie*, 1879, cited in De Quirós, *op.cit.*, 11 and 42. Bordier (1841–1910) was an anthropologist and professor of medical geography at the Paris École Publique d'Anthropologie, founded in 1876 by the physiologist Paul Broca (1824–1880), of whom Bordier was a disciple. Broca was a follower of Darwin and founder of the modern French School of anthropology in 1861. *Dictionnaire de biographie française*, vi, 1954, 1086 and vii 1956, 383.

13. Duval (1844–1907) published several important anatomy texts and was Professor of Zoological Anatomy at the École d'Anthropologie in Paris from 1880–90. *Dictionnaire de biographie française*, xii, 1970, 982–3.

14. Duval and Bical, *op.cit.*, 3 (my italics).

15. First developed in Lombroso, *op.cit.*, *passim*.

16. De Quirós, *op.cit.*, 6–7.

17. 'Comtesse Louise', 'Lettres familières sur l'art', *La France nouvelle*, 1–2 May 1881, 3, cited in Charles W Millard, *The Sculpture of Edgar Degas* Princeton, 1976, 29, hereafter referred to as Millard, 29 & n 13. Zola's character Nana first appeared in *L'Assommoir*, published in serial form in 1876, and *Nana* was published in 1880; see also n 40, below.

18. Petrus Camper, *op.cit.*, quoted in Duval and Bical, *op.cit.*, 22, n 1.

19. Duval and Bical, *op.cit.*, 22, n 1 and 27.

20. H Kuhnholtz, *Reflexions de Floriano Caldani sur l'anatomie appliqué à la peinture, traduites de l'italien et accompagnées d'un avant-propos et de notes sur le même sujet . . .* Montpellier, 1845, quoted in Duval and Bical, *op.cit.*, 27.

21. Dr Galtier-Boissière, *La Femme: conformation, fonctions, maladies & hygiène spéciales*, Paris, n.d. [1905], 2. A populariser of science, Emile Galtier-Boissière (1857–1919) was typical in his indiscriminate marrying of artistic and scientific data. He used the Rembrandt etching, and measurements of skulls found in the *caverne de l'homme mort* in Lozère, to argue that primitive woman in fact had a larger brain capacity (and thus greater intelligence) than the modern Frenchwoman; in support of his argument he cited the work of Paul Broca, see n 12, above.

22. Lombroso and Ferrero, *op.cit.*, 101, 102, 28, 113, 112 (my italics); his definitions of criminal sexual deviancy in woman centre on masturbation and prostitution. Degas' model was apparently proud of her long black hair, which she is said to have worn hanging down her back when she danced; the American collector friend of Mary Cassatt, Mrs Havemeyer, recalled the statuette's real hair: 'How wooly the dark hair appeared.' (Mrs Havemeyer, *From Sixteen to Sixty*, 254–5, quoted in Reff, 247). Most critics found the sculpture's bony anatomy suggested an adolescent girl, and the muscular body described with relish by the novelist Huysmans as '. . .coloured flesh palpitating, lined with the work of its muscles . . .' was also considered physiologically in keeping with a dancer subject. However, for Elie de Mont the skinny, wrinkled body was a sign of age, not youth. (Joris Karl Huysmans, 'L'Exposition de indépendants en 1881', *L'Art moderne*, Paris, 1908, 250–55, and Elie de Mont, 'L'Exposition du Boulevard des Capucines', *La Civilisation*, 21 April 1881, 2, quoted in Millard, 124, 120).

23. No 34; see facsimile catalogue in Charles S Moffett, *The New Painting: Impressionism 1874–1886*, Oxford, 1986, 311; hereafter referred to as Moffett. On the genesis of the sculpture, see Millard, *passim.*, and Reff, 239–248; for additional references, see Richard Thomson, *Degas, The Nudes*, London, 1988, 231, n 5. Millard (p 9) argues that the sculpture Degas planned to exhibit that year was in fact the nude study (fig 12), on which he experimented '. . .up to the last possible moment . . .', and for which he cast a plaster plinth. Yet the catalogue entry, and comments by the critic Goetschy suggest the final clothed version was already planned, if not under way when the 1880 exhibition opened; see Gustave Goestchy: 'Indépendants et impressionnistes', *Le Voltaire*, 6 April 1880, quoted in Moffett, 309, n 43.

24. Caillebotte in a letter to Pissarro, 28 January 1881: 'Degas' case is not enough for me'. Quoted in Moffett, 340; Anon, *Chronique des Arts*, 18, 1881, 109–110, quoted in Reff, *op.cit.*, 242.

25. Jules Claretie, 'La vie à Paris: Les artistes indépendants', *Le Temps*, 5 April 1881, quoted in Roy McMullen, *Degas, His Life, Times, and Work*, London, 1985, 338; Paul Mantz also referred to the display case as a cage, 'Exposition des oeuvres des artistes indépendants', *Le Temps*, 23 April 1881, quoted in Millard, 121.

26. C E (Charles Ephrussi), *op.cit.*, 126, quoted in Millard, 120 (my translation).

27. cf. the pictures of the Salon reproduced in J-B Crespelle, *Les maîtres de la belle époque*, Paris, 1966, pls 19–21. Reff, 245, suggests the Degas' high viewpoint drawings of the model were intended to ' . . . anticipate that of the spectator looking down at the statuette in its case'. However, it is unlikely that the two-thirds life-size figurine would have stood on the floor in its glass case; under life-size sculptures were normally raised so as to confront the viewer at eye level. Drawings of a subject from numerous angles were integral to Degas' working method (see Reff, 245, and n 20), and would have been essential to a painter experimenting in a new, especially a three-dimensional, medium.

28. Suggested by Reff, 242–3. A further example is the glass case shown as housing Henri Rouart's Eygptian Antiquities, in Degas' 'Portrait of Hélène Rouart in her Father's Study', 1886, Cat. 6.

29. Elie de Mont, *op.cit.*, quoted in Moffett, 362; Henry Trianon in *Le Constitutionnel*, 24 April 1881, paraphrased by Druick and Zegers, *op.cit.*, 211, and quoted in Moffett, 362.

30. 'Comtesse Louise', *op.cit.*, quoted in Millard, 29, and his comments, n 13.

31. Paul Mantz, *op.cit.*, here quoted from McMullen, *op.cit.*, 338.

32. Jules Claretie, *op.cit.*, quoted in Moffett, 341.

33. Paul Mantz, *op.cit.*, quoted in Millard, 122, my translation; Elie de Mont, *op.cit.*, quoted in Moffett, 362. On the debate over the impact of work on physiognomy, and Huysmans's reference to it in respect of Degas' dancers, see Druick and Zegers, *op.cit.*, p 206. On the state of Classical Ballet at the Opéra in this period, see Anne Wagner, *Jean-Baptiste Carpeaux, Sculptor of the Second Empire* New Haven and London, 1986, and Alex Potts, 'Dance, Politics and Sculpture', *Art History* no 1, x, March 1987, 91–109.

34. The orthography of the name varies; Millard argues that Goethem is the correct form, and see his discussion of the model, 8–9, n 26; most writers use this form; Goethen is used by Reff, 245; some writers use Goeten. The model was aged fourteen in 1878; see Millard, as above; Reff, 245 and n 19 (333), contends that her début at the Opéra took place in 1888, and thus she could not have been older than fourteen in 1880; yet a début at twenty-two is still late for a dancer. Millard puts forward evidence that she was already performing in 1882, aged seventeen, and both he and McMullen, *op.cit.*, 333, note that she is recorded as having been born on 17 February 1864.

35. McMullen, *op.cit.*, 333.

36. C E [Charles Ephrussi], *op.cit.*, 127 quoted in Reff, 246.

37. Mantz, *op.cit.*, quoted in Millard, 122, my translation, my italics.

38. Mantz, *op.cit.*, quoted in Moffett, 341, my italics.

39. Eunice Lipton has noted that unlike Daumier, Degas' caricatural treatment was exclusive to working class types; see *Looking into Degas*, 1986, 101 and 203, n 34. That Degas might have been opposing depictions of '...modern life's semi-noble and semi-comic aspects...' in his *Milliners* exhibits in 1886, is suggested by Martha Ward in Moffett, 431. The simian features of the working girls are contrasted with the finer features of their customers to emphasise class difference.

40. Gustave Geffroy, 'L'Exposition des artistes indépendants', *La Justice*, 19 April 1881, quoted in Moffett, *op.cit.*, 342; Mantz, *op.cit.*, quoted in Millard, 121, my translation. On the conflicting identifications of the men in Degas' criminal profiles, and on the public controversy surrounding the trial including, as contemporaries saw it, the accuseds' *L'Assommoir*-like real-life exploits, see Druick and Zegers, *op.cit.*, 207–10; see also their discussion, *ibid.*, 209–10, referred to in n 1, above, of the scientific interest in this trial, which prompted the article in *La Nature*.

41. Galton's ideas were first published in 1865; see Daniel J Kevles, *In the Name of Eugenics, Genetics and the Uses of Human Heredity*, Harmondsworth, 1986, esp ch 1; T R Malthus's *Essay on Population* was first published anonymously in 1798. Criminal *sociology* developed a following only slowly in France, by comparison to the seductive popularity of criminal anthropology; see De Quiròs *op.cit.*, esp 55ff.

42. Fronia E Wissman, 'Realists among the Impressionists', in Moffett, 341; Claretie, *op.cit.*, quoted in *ibid*. Amongst the reviews of this exhibition, see for example that of Trianon, *op.cit.*, who stated that Degas '...seems to be one of these Naturalists...' because all his entries were 'disagreeable things'. Quoted in Moffett, 340.

43. Georges Rivière, *Mr. Degas, Bourgeois de Paris*, Paris, 1935, quoted in Lipton, *op.cit.*, 163.

44. On the use of wax in 'popular' sculpture – like Madame Tussaud's, with which Degas was probably familar – see Reff, 246–8. On Degas' knowledge of Neapolitan religious wax figurines, see Millard, 64; he also discusses the contemporary interest in French academic circles in Greek polychrome sculpture. Degas' reviewers also referred to shop dummies, a contemporary novelty which undoubtedly contributed to Degas' conception, as it did to Zola's work (see Reff, 248). On the connection with wax mannequins used in ethnographic exhibitions of the period, see Druick and Zegers, *op.cit.*, 210–11. Degas may well also have been aware of the tradition, particularly in Italy, of wax anatomical figures, for a discussion of which see Ludmilla Jordanova, 'Gender, Generation and Science: William Hunter's Obstetrical Atlas', in Bynum and Porter (ed), *William Hunter and the Eighteenth-century Medical World*, Cambridge, 1985, ch 14.

45. Trianon, *op.cit.*, quoted in Moffett, 341.

46. Peter Stallybrass and Allon White, *The Politics and Poetics of Transgression*, London, 1986, 128, their italics; they are discussing the nineteenth-century bourgeois view of the slum.

47. De Mont, *op.cit.*, quoted in McMullen, *op.cit.*, 339; Huysmans, *op.cit.*, quoted in Moffett, 362.

HÉLÈNE ROUART
IN HER FATHER'S STUDY

Dillian Gordon

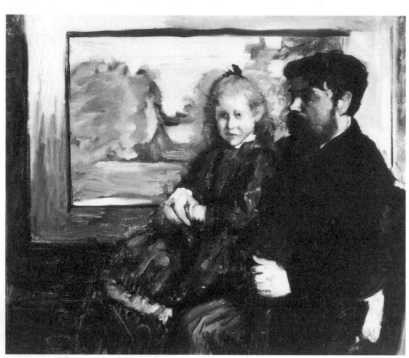

1. Degas, 'Hélène Rouart on her Father's Knee'. New York, Private Collection.

2. Henri Rouart, 'Landscape'. Private Collection.

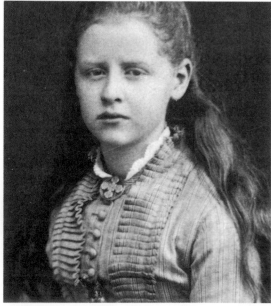

3. Photograph of Hélène Rouart aged about ten.

The portrait of Hélène Rouart (p 31), painted in about 1886, was one of Degas' last major portraits. Degas had, in the 1870s, painted her as a child, seated on her father's lap. It is possible to trace the evolution of his ideas from the early to the late portrait through a series of preparatory sketches which reveal something of Degas' working methods and his relationship with the Rouart family.

From the very beginning, portraits had been fundamental to Degas' life as a painter. His early paintings were all portraits, and were all of his family. Throughout his life, Degas continued to paint portraits of his family, of his friends, and of the friends of his friends. As far as we know, he never painted a portrait to commission. For him portraits were the natural expression of affection and of the psychological insight born of knowledge and understanding. Strangers – such as laundresses, ballet dancers, prostitutes, singers – he exposed with a raw frankness. But it was with discretion and dignity, keeping the secret of familiarity, that he explored in paint the relationship to the world and to each other of the people closest to him.

One of these was Henri Rouart with whom Degas had been at school at the Lycée Louis-le-Grand in Paris. The two men renewed their friendship in 1870 during the siege of Paris, when they both served in the same artillery corps. Thereafter they met regularly and corresponded by letter when apart. Henri Rouart was a wealthy industrialist who made his fortune inventing a machine for making ice (1862) and one for the transmission of telegrams (1867). He was a brave and discerning collector. He owned a few Old Master paintings by such artists as Chardin, Fragonard, El Greco and Goya, but he was above all a bold and generous champion of contemporary painters while they were struggling for recognition. When he died in 1912, his collection included works by Corot, Millet, Delacroix, Courbet, Manet, Renoir, Daumier, Lépine, Gauguin, Jongkind, Monet, Cézanne, Berthe Morisot, Mary Cassatt and Puvis de Chavannes, as well, of course, as several by Degas. It was a dazzlingly rich collection which drew artists and connoisseurs alike to the elegant Paris house, 34 rue de Lisbonne (a building which had been designed by Degas' brother-in-law, Fèvre), where paintings were crammed from wall to ceiling. Degas dined weekly with the Rouart family and their circle of friends. One of the habitual guests, the poet Paul Valéry, described the scene:

> Every Friday the faithful Degas, sparkling and unbearable, enlivens the dinner table at M Rouart's. He spreads wit, terror, gaiety. He mimics piercingly and overflows with caprices, fables, maxims, banter. He has all the characteristics of sharply intelligent injustice, unerring good taste, and a passion which is concentrated but lucid. He pulls to pieces men of letters, members of the Institute, hypocrites, upstart artists. He quotes Saint-Simon, Proudhon, Racine and the bizarre remarks made by Monsieur Ingres... I can hear him now... His host, who adored him, used to listen with admiration and indulgence, while the other guests... relished these displays of irony, aesthetics or violence coming from this wonderful magician with words.

Henri Rouart was also a painter. Together with Degas, he was amongst the signatories to the charter of the first Impressionist exhibition, held in 1874. But, unlike Degas, he was primarily a *plein-air* painter, and landscape painting was a subject of fierce debate and amicable teasing between them. Degas told Vollard (the dealer): 'There's Rouart who

painted a watercolour on the edge of a cliff the other day! Painting is not a sport...'. But Degas shared Rouart's pioneering passion for early Corot landscapes, unfashionable at that date. So when he included a large window-like landscape, deliberately ill-defined, in the background of his double portrait of Henri Rouart with his eldest child, Hélène, sitting on his lap (fig 1), it may have been a gesture of homage to his taste as a collector. Or it may have been a barbed comment on Henri Rouart's predilections as a landscape painter. Jean-Dominique Rey has suggested that it may be a rough approximation of a landscape painted by Henri Rouart, probably near his country home at La Queue-en-Brie (Private Collection) (fig 2).

The portrait of Hélène on her father's knee, wearing a striped dress, her red hair tied up in a bow, probably dates from soon after the reunion of the two school friends in 1870. Hélène, who was born in 1863, was about ten when it was painted. Degas may have made use of a photograph (fig 3) to capture her bewildered far-away look. Already in childhood, she seems lonely and melancholic.

From this early portrait stemmed Degas' several ideas which he finally resolved in the large portrait of Hélène as a young woman (see p 31) painted in about 1886.

It was above all Hélène's complexion and colouring, and her red hair, which attracted Degas as a portraitist. In October 1883, he mentioned that he was thinking of painting her portrait in a letter to Henri Rouart, who had taken his family to Venice:

I should have liked to come with you and begun the portrait of your daughter, there in Venice, where her hair and colouring are of the kind so admired in the past.

Degas was referring to the red-haired women in the paintings of such artists as Titian and Veronese. Again in August 1884, when Hélène was twenty-one, he wrote to Henri Rouart from Normandy:

Your daughter who has always had such a pretty colouring must by now be dazzling.

He seems to have begun the portrait around 1884 or 1885 – in 1885 he wrote one of his despairing and depressed letters to Henri Rouart:

Very little time given over to the portrait of your daughter despite the best will in the world. Oh my God! Come back quickly. I hate writing letters.

The several pastels and sketches for her portrait bear the dates 1884 and 1886. Scholars have recently tended to think that these dates were added later and are to be disregarded. However, if they are accepted as reasonably valid, a certain logic emerges as underlying the development of Degas' ideas. Two distinct ideas can be detected in these preliminary studies for the portrait, themes which were to fuse into one in the final version.

A reference to Henri Rouart's collection was implicit from the outset. In about 1884 Degas seems to have planned a double-portrait of Hélène with her mother, perhaps to complement the earlier portrait of Hélène with her father. A quite highly worked pastel (fig 4) bearing the date 1884, shows Madame Rouart admiring a terracotta Tanagra figurine, presumably an item from Henri Rouart's collection. Tanagra figurines (fig 5) were extremely fashionable at this time and during the 1880s were being excavated from the necropolis at Myrina. Objects from Myrina were acquired by the Louvre in 1883. Very roughly sketched into the background are the blue/green stripes of Hélène's dress.

A pencil drawing (fig 6) of about 1884 shows a variant of the same composition, although this time it is Madame Rouart who is only faintly adumbrated and Hélène drawn in more detail, although still roughly sketched. By now Hélène, with her hand on her hip and her shawl drawn across the body, herself echoes the traditional pose of the Tanagra figurine. Hélène's classical features and the sharing of her name with the most famous Greek beauty (Offenbach's opera *La belle Hélène*, which had taken Paris by storm in 1864, could have served as a

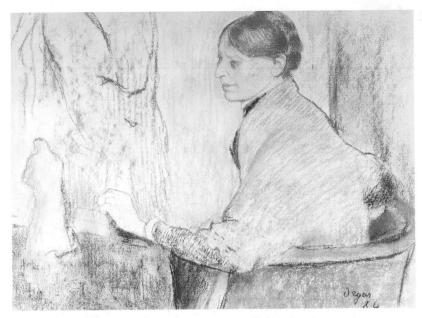

4. Degas, Pastel study of Madame Rouart. Karlsruhe, Staatliche Kunsthalle.

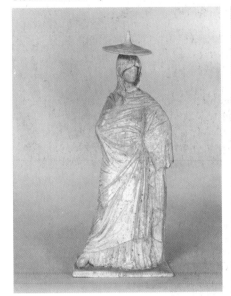

5. Hellenistic Terracotta Figure of a Woman 330–300 BC. London, The British Museum.

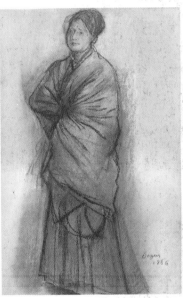

6. Degas, Pencil study of Hélène Rouart. London, Private Collection.

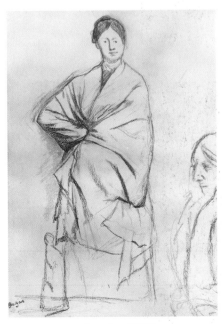

7. Degas, Pastel study of Hélène Rouart. Los Angeles County Museum of Art, Mr and Mrs William Preston Harrison Collection.

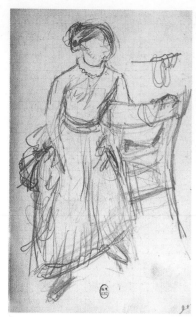

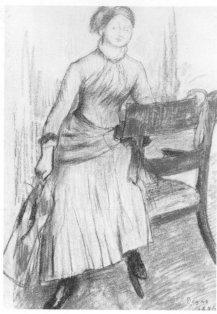

8. Degas, one of the pencil studies of Hélène Rouart. Paris, Bibliothèque Nationale.

9. Degas, Study of Hélène Rouart. London, Private Collection.

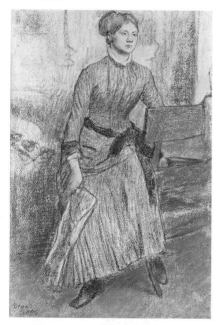

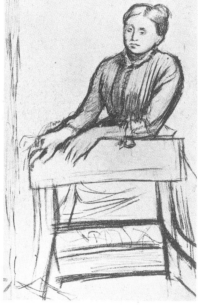

10. Degas, Pastel study of Hélène Rouart. Cologne, Kunsthaus Lempertz.

11. Degas, Study of Hélène Rouart. Present whereabouts unknown.

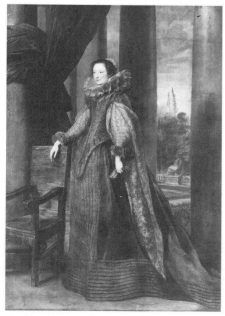

12. Van Dyck, 'Marchesa Geronima-Spinola-Doria'. Paris, Musée du Louvre.

reminder) may have suggested the association with a Greek terracotta. A more finished pastel (fig 7) bearing the date 1886, shows Hélène still in the Tanagra pose, but facing the other way, suggesting that by this time Degas had decided to exclude Madame Rouart. J S Boggs, in an article on the subject, has suggested that this was because Degas discovered a tension in the relationship between mother and daughter. However, the discernment of tension between husband and wife had not deterred him from translating it to his portrait of the Bellelli family. Perhaps it was simply because Madame Rouart was unwell. In any case, in about 1884–5 Degas wrote to Madame Rouart that he intended substituting her husband for herself in the portrait:

> For I wish to put him in your place in the portrait and it would be helpful for me first to sketch his proportions in relation to his daughter.

However, no sketches survive showing Henri Rouart with his daughter. And it seems that at this point Degas changed his intention. Instead of implying Henri Rouart's presence through the inclusion of an item from his collection, Degas used his empty chair.

Just as Degas' earlier portrait of Hélène as a little girl had shown her seated on her father's knee, so now she was to be seated on the arm of her father's chair. The chair, which still belongs to the Rouart family, came from the family of Madame Rouart, whose father, Iacob Désmalter, had been a well-known cabinet-maker. Degas later showed Henri Rouart as an old man sitting in the very same chair in a pastel of about 1895 (Private Collection).

Very rough studïes (fig 8) at the end of a notebook (Carnet 37, pp 204–207), whose other studies are datable 1882–1884, show the germ of Degas' idea, with Hélène perched on the arm of the chair. Then came a pastel study (fig 9), bearing the date 1886, of her in a faintly-striped blue dress (perhaps a reference to the striped dress in the childhood portrait), with a slightly turquoise sash strengthened with blue, drawn across the body like the shawl of the Tanagra pose. A more highly finished pastel (fig 10) shows the dress still a faintly striped blue one, and round her waist a deep blue sash. In both studies the background is indeterminate – strokes of yellow, brown, and pale green. The object she holds in her right hand is ambiguous, perhaps a vestige of the palm fan often held by Tanagra figurines.

And then follows a rough drawing (fig 11), where the chair has been turned round and Hélène is standing behind it, resting her hands along its back.

When Degas saw portraits by Van Dyck during a visit to Genoa in 1859, he wrote to Moreau that: 'No-one has ever rendered the grace and refinement of woman... the way Van Dyck has', and he made a sketch of the portrait of Paolina Adorno, Marchesa Brignole-Sale, a woman standing by an empty chair. The motif of an empty chair, used to refer to the absence of a loved person, is a traditional one, but it is worth remarking that one of Van Dyck's finest portraits, which Degas may have seen, was the portrait of the Marchesa Geronima-Spinola-Doria, showing her resting her hand on the back of a chair (fig 12). This painting was in France by at least 1905, when it was in the collection of Alphonse de Rothschild. Given Degas' obsession with Old Master paintings, it seems likely that he deliberately took a backward look at the artist who, for him, captured the essence of woman, when he began on the final portrait of Hélène Rouart.

It is characteristic of Degas, that in the numerous studies, Hélène's features are only vaguely sketched in; only towards the end did he begin to study her face. For him, the expressive potential of the pose came before all else. He wrote that one should 'make portraits of people in familiar and typical attitudes and especially give the same choice of expression to the face that one gives to the body'.

When he eventually came to make a detailed charcoal drawing for the final portrait, it was not of her features, but of her hands (fig 13).

This fine and sensitive drawing is the only surviving study made specifically for the final portrait and it demonstrates the importance Dega attached to the hands: they eventually provided the focal point of the entire composition (fig 14).

X-ray photographs of the painting show that Degas had fully worked out his ideas by the time he came to the portrait and made no major changes to the final composition.

In it, Degas combines the two themes explored in the preliminary sketches: Hélène's stance and the proud tilt of her head stem from the studies of her in the pose of a Tanagra figurine. Now she stands behind her father's chair: she rests on its back, as if seeking support and comfort. She is still dressed in a blue dress with white cuffs and collar, and deep blue sash, but no longer is the dress only faintly striped; instead, a complicated assortment of different shades ranging from violet to turquoise create an overall effect of rich and electric blue. The choice of deep blue for her dress may also have been influenced by an item in Henri Rouart's collection. One of his most treasured possessions was 'La Dame en Bleu' painted in 1874 by Corot (fig 15). The resemblance goes beyond merely the colour of the dress. The picture shows a pensive young woman holding a fan, resting against a piece of furniture, and on the wall in the background are paintings – two landscapes by Corot.

On the wall behind Hélène Rouart hangs the painting of the 'Castel dell'Ovo in Naples' by Corot, painted in 1828 (fig 16).

The inclusion of paintings within painting to widen the terms of reference with subtle allusion is, of course, a traditional device of painters, and one extensively used by Degas. Another iconographic convention, dating back to the Renaissance, is to show collectors with items from their collection. Here the two themes are combined. The device of showing Hélène with one of the Tanagra figurines from Henri Rouart's collection has been expanded to show her with several objects from his collection, each with its own particular reference. The inclusion of the seascape by Corot was not only a reference to Henri Rouart, who had pioneered the taste for early Corot landscapes, owning over forty paintings by him: it would have also had very personal associations for Degas himself.

Degas was of Neapolitan descent and frequently visited Naples: he made a visit there in January 1886, probably the very year he was engaged on this portrait. He himself had made several sketches of the Castel dell'Ovo in the early 1860s, with notes which show him captivated by the colours of the Bay of Naples and silhouette of the fortress:

> the Castel dell'Ovo produced a curious effect, greenish and black as in winter, outlined against the roseate slopes of Vesuvius.

Degas excluded Corot from his vituperative attacks on landscape painters and admired him enormously, wittily summing him up as: 'un Ange qui fume la pipe' ('an angel smoking a pipe'). During 1898 and 1899 he bought six landscapes by Corot for his own collection.

Below the Corot seascape hangs a drawing, dating from about 1851–2, by the French realist painter Jean-François Millet, of a peasant girl seated at the foot of a haystack (fig 17). Again this was one of the prize items from Henri Rouart's collection. One critic described how Henri Rouart was particularly fond of 'cette page d'humanité vraie'. Henri Rouart used to go frequently to Barbizon at weekends to talk with Millet and paint with him, and had over a dozen paintings by him in his collection, as well as many drawings. In including this drawing, Degas was perhaps underlining the affinities between the poor peasant girl and the daughter of a wealthy Parisian industrialist, despite their different social backgrounds.

It may initially have been the sepulchral association of the Tanagra figurine which led to Degas' including three Egyptian statues in a glass case behind Hélène Rouart. The figure in the foreground is identifiable as a Ptah-Seker-Osiris (not an *ushbati* figure as has been said). Wooden mummiform statues of this funerary deity were placed in tombs from

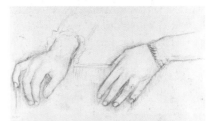

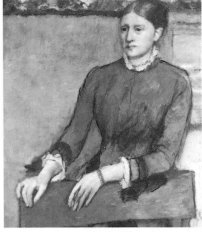

13. Degas, Charcoal study of hands. Private collection.

14. Degas, detail of 'Hélène Rouart in her Father's Study'. London, The National Gallery.

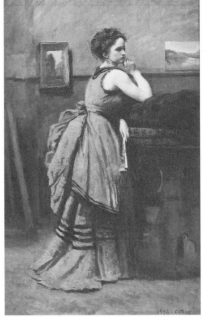

15. Corot, 'La Dame en bleu', 1874. Paris, Musée du Louvre.

17. Jean-François Millet, 'Peasant Girl seated by a Haystack'. c1851–2. Paris, Musée du Louvre, Cabinet de Dessins.

16. Corot, 'Bay of Naples with the Castel dell'Ovo', 1828. Private Collection.

18. Ptah-Seker-Osiris. Paris, Rouart Collection.

19. Photograph of the interior of 34 rue de Lisbonne, Paris.

20. Chinese embroidery. Late 19th century. Edinburgh, Royal Scottish Museum.

the late New Kingdom and were sometimes hollowed out to contain papyrus rolls inscribed with the Book of the Dead. The base often contained fragments of the mummified body. Henri Rouart visited Egypt in 1878 and had perhaps brought the statues back with him then. One of the statues still belongs to the Rouart family (fig 18)

French interest in Egypt dated from the Napoleonic Wars and the taste of the French Romantic writers for the exotic stimulated this interest. Several writers visited Egypt, including Nerval in 1843 and Flaubert in 1849. Others did not, but wrote about it all the same. Victor Hugo grew lyrical over marble pyramids and a sphinx of pink granite and green marble. Gautier wrote his *Roman de la Momie* long before he visited Egypt in 1869, pillaging from information published by travellers and archaeologists. It was this novel, pulished in 1857, which first aroused Degas' interest in Egypt, and he made numerous copies after Egyptian monuments in which the Louvre was rich.

Degas had made similar reference to the contrast between the living and the dead in his depiction of Mary Cassatt admiring the Etruscan sarcophagus in a glass case in the Louvre. It has been suggested that this was an allusion to the 'Meeting of the Three Living and the Three Dead', a popular medieval subject. In fact, Degas had made a copy of the fourteenth century fresco 'Il Trionfo della Morte' by Francesco Traini, which included this subject, when he visited the Camposanto in Pisa in 1859.

The Egyptian statuettes are actually quite small, only about 700 mm high, and were displayed on a table in the Rouart household (fig 19). Degas has played with the proportions and, even allowing for the fact that the statues are to be read as well forward on the desk, level with the back of the chair, they seem disproportionately large. They may have been intended to underline the reference to Henri Rouart, ever present by implication through his pile of paper and empty chair.

Indicative of the 19th century taste for oriental art is the Chinese wall-hanging which draws the whole composition of disparate items together around Hélène across the top of the picture. It is embroidered with kylins and is probably 19th century (fig 20). Such embroideries were originally used at weddings or hung up around family altars. Perhaps it was included as a reference to Hélène's marriage in 1886 to Eugène Marin, an engineer. The study of her hands shows her wearing a ring, although this is not included on the possibly unfinished left hand in the final portrait.

The many layers of allusion which one can tease out from the objects from Henri Rouart's collection which surround Hélène may have been consciously intended by the artist, or may have been involuntary. Certainly the objects seem to have been specially selected, since contemporary photographs show the interior of 34 rue de Lisbonne chaotically crammed with a bewildering variety of collector's items and paintings. Degas was creating a deliberately eclectic and symbolic image. But the meaning of the portrait would have been apparent only to Degas, the Rouart family and their circle of friends, since the objects are so summarily and sketchily painted as to be only recognisable if one is familiar with the originals.

The haunting image of Hélène herself, hemmed in by the objects from her father's collection, is made all the more remote by the fact that she refuses to meet our gaze. Her expression is solemn and melancholy, perhaps because of the illness of her mother who died in 1886. There is no evidence otherwise that her life was unhappy. She had three children by her husband, Eugène Marin, and died in 1929, surviving Degas by twelve years. Her portrait was still in his studio when he died in 1917.

Degas' associations with the Rouart family continued until his death. He made several pastel studies of Henri Rouart with his son Alexis, of Alexis' wife with her two children, and of another son Louis

with his wife. And it was to Henri Rouart in 1896, on the birth of one of Henri's grandchildren, that Degas wrote one of his bleakly sad letters:

Voilà ta postérité qui se remet à marcher. Tu seras béni, homme juste, dans tes enfants et les enfants de tes enfants. Je fais, dans mon rhume, des réflexions sur le célibat, et il y a bien les trois quarts de triste dans ce que je me dis. Je t'embrasse.

(Now your posterity is once more under way. You will be blessed, just man, in your children and in the children of your children. I have a cold and as I reflect on my bachelorhood at least threequarters of my thoughts are sad ones. I embrace you.)

This essay is reprinted here with permission from The National Gallery.

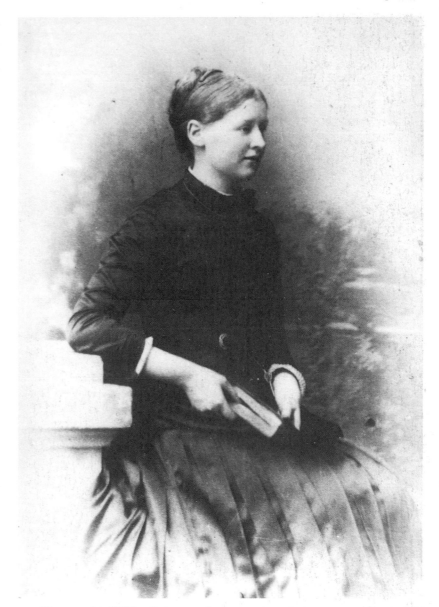

21. Photograph of Hélène Rouart aged about 23.

Catalogue
Richard Kendall

Edgar Degas grew up in surroundings where portraiture was the norm rather the exception. His father was a banker who had eighteenth-century pastel portraits in his collection and the young Edgar was recorded by an indifferent portrait-painter on more than one occasion[1]. Many early portrait photographs of the artist and his relatives survive and the majority of Degas' first attempts at oil-painting were studies of his own immediate family. During his travels in Italy and his early training as an artist, Degas made copies from the great portraitists of the past, and it is significant that six of the eight pictures he subsequently exhibited at the official Salon were portraits. Even more significantly, all six of these paintings represent women, either individually or with their families, and it has been argued that Degas showed a particular preference for, and sensitivity towards, the portrayal of the opposite sex[2]. Certainly, Degas continued to make portraits of his female friends and acquaintances throughout his life and substantially more than half the total number of his portraits are of women.

The portrait is perhaps the most socially selective of all Degas' imagery. When painting the theatre, the race-track and even the nude, Degas delighted in the interaction of the classes or the ambiguity of their social context. As a portraitist, on the other hand, his attention was directed almost exclusively towards women of his own class and, with few exceptions (every generalisation about Degas has important exceptions), there are no true portraits of the working-class women who provided the subjects for so many of Degas' pictures. The portrait, by tradition and almost by definition, is a study of the appearance and character of an individual. For that individual to be portrayed, he or she must be perceived to be interesting or remarkable enough to justify the artist's attentions. Degas did not accept commissions, and his own portraits represent the members of his family and the wives of his friends, women of known talent (such as painters and musicians) and notable society hostesses. As a true child of his age, he made exceptions for the self-made women of the theatre and the ballet, but essentially his portraits reflect the attitudes and prejudices of his upper-middle-class background.

Broadly speaking, Degas' portraits of women can be divided into two separate but overlapping groups, the intimate and the public. The first group is frequently associated with the earlier part of his career and is the most traditional in appearance, often featuring a centrally placed figure and a symmetrical or balanced composition. Typically, the woman is in a domestic interior or against a neutral background, but is occupied principally with the business of being painted. The emphasis is on her face, and as a consequence the artist (and by extension the spectator) appears to enjoy a close, even intimate, relationship with her. In many cases the woman returns our gaze, and we become aware of the reciprocal transaction between the viewer and the viewed. The woman's features are finely described and we find ourselves, literally, face-to-face with another discrete, particularised human being.

The second group of female portraits is in many ways the converse of the first. Here, the figures are generally engaged in a specified leisure activity which takes place outdoors or in a public context. Many of these activities imply movement, which is often conveyed through an asymmetrical composition or a series of diagonals within the picture. The women in this group are seen from a greater distance, and attention is drawn to the expressive possibilities of their bodies as well as their faces. Gesture, deportment and view-point are used to telling effect, while the detailed description of costume and accessories helps to suggest something of the sitter's status and personality. These women often avert their gaze, preoccupied as they are by the business in hand, and we are asked to believe in the plausibility of their actions and behaviour. Our relationship with them is more distant, but the description of their roles in Degas' clearly defined social hierachy is, if anything, more complete[3].

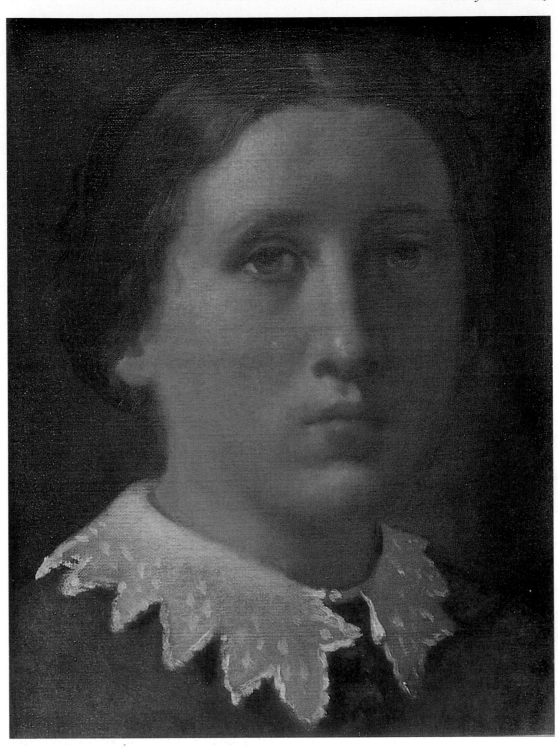

1. *Portrait of Marguerite, Sister of the Artist*
c1856
Oil on canvas
330 × 250 mm
Walsall Leisure Services Department
Art and Cultural Services Division
from the Garman-Ryan Collection

Degas was the eldest of five children and during his artistic apprenticeship he often persuaded his younger brothers and sisters to pose for his experiments in portraiture. This study of Marguerite belongs to a substantial group of small drawings and paintings of his family and relatives produced while the artist was in his twenties. Considering the familiarity between the artist and his subjects, these pictures are remarkably sombre in mood and construction. Degas' choice of dark backgrounds and subdued colouring shows his reverence for a particularly severe tradition of European portraiture, while his use of dramatic side-lighting follows the standard academic convention of the day. The placing of Marguerite's head almost centrally within the rectangle gives further stability and solemnity to her image, and it is only the frankness of her gaze that introduces animation into this otherwise melancholy countenance. The effect is not unlike the many self-portraits which Degas produced at this time, in which a single life-size head fills the canvas and stares straight back at the viewer. The scale of the head suggests that we, like the artist, enjoy a close proximity to the subject of the portrait, while the steady exchange of eye-contact indicates a confident relationship amongst equals.

Tradition has it that Marguerite was the artist's favourite sister. She was eight years younger than Degas and was drawn and painted by him throughout her adolescence and early womanhood. Marguerite was about fourteen years of age when this portrait was painted, her severe hairstyle and costume probably representing her appearance as a school-girl[1]. At this date, Marguerite showed a striking resemblance to her brother, with a similarly pronounced nose and slightly asymmetrical eyes. An etching Degas made of her in about 1862 records the finer features of her mature face, though it is perhaps significant that the artist repeated the intimate, frontal composition in this later work[2]. In 1865 Marguerite married the architect Henri Fevre and moved to Buenos Aires, where she continued to correspond with her brother. One of the children of this marriage, Jean Fevre, looked after Degas in his old age and wrote one of the most vivid accounts of his career (in which this portrait is reproduced) called *Mon Oncle Degas*[3].

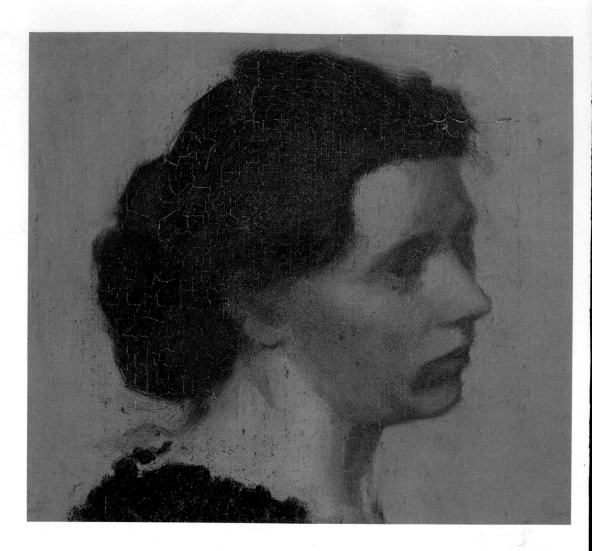

2. *Head of a Woman*
c1873
Oil on canvas
175 × 197 mm
Trustees of the Tate Gallery

Little is known of the history of this painting or the woman depicted. Its exceptionally small scale indicates that it may be a study for another work or possibly a fragment cut from a larger canvas; two other pictures by Degas, known only in black-and-white photographs, appear to represent the same anonymous sitter[1]. Unusually for Degas, the painting itself offers few clues about the identity of the model or the significance of her pose. The women wears no jewellery or other accessories and neither her costume nor the background of the painting are sufficiently developed to elucidate the mystery.

Apparently unaware of the spectator, the woman seems preoccupied by her own thoughts rather than engaged by her surroundings. The morose expression on her face and the subdued range of colours suggest that the picture may belong to a group of Degas' studies of women that has never been given the prominence it deserves; between 1871 and about 1873, Degas produced a series of small paintings that are neither female portraits nor narratives of a conventional kind, but rather explorations of the mood or the emotions of the woman portrayed. One sequence has been associated with melancholy, sulking and weeping, while another deals with female convalescents, medical patients and the sightless[2]. Many of the pictures have been related to the period of the Franco-Prussian War or to Degas' subsequent visit to the Untied States, at a time when his own health was causing concern and when he frankly regretted his bachelor existence. In conjunction with Degas' studies of maternity and child care, these pictures appear to form part of a wider project to examine and document all aspects of female experience in its most public and private aspects[3]. They have much in common with the studies of female life and psychology to be found in the novels of Gustave Flaubert and the Goncourt brothers, while Degas' systematic treatment of a wide range of female behaviour echoes the quasi-scientific approach of Emile Zola.

3. *Head of a Woman*
c1874
Oil on canvas
321 × 267 mm
Trustees of the Tate Gallery

The bold features and striking colouration of this portrait contrast in almost every way with Degas' 'Portrait of Marguerite' and the Tate Gallery's other 'Head of a Woman'. Beside the solemnity of Marguerite, this sitter seems jovial, almost jaunty, while the ruddy glow of the paint surface evokes a warmth and conviviality quite at odds with the smaller 'Head of a Woman'. The heavily textured canvas and the bold strokes of the brush are not typical of Degas' practice at this point in his career, and the unusual tonality suggests an early experiment in colour and technique. A blackish under-painting is visible in many places and has almost certainly become more conspicuous since the picture was painted, due to a tendency for oil-paint to increase in trans-lucency as it ages[1].

One of the few references to this painting in the Degas literature describes the sitter as having a 'fat, common face'[2]. The description is both misleading and inadvertently instruct-ive. The apparent coarseness of the woman's features is due largely to the unorthodox tech-nique used by the artist and the consequent alterations in the paint surface, and there is every reason to believe that she once enjoyed an unblemished complexion. The implicit assumption that the 'fat' face is associated with a 'common' individual is, however, worth examining. It has often been remarked that the educated nineteenth-century mind preferred to think of ugliness as a lower-class attribute, but the briefest glance at contemporary paint-ings and photographs reveals the absurdity of this prejudice. Several of Degas' female rela-tives, who would certainly not have regarded themselves as 'common', had plump faces and heavy features, and the artist himself painted a number of society ladies with generous pro-portions[3].

While the identity of the sitter in 'Head of a Woman' is not known for certain, the empha-sis on her open and familiar gaze is a device used principally in portraits of women from Degas' own social class. Her hairstyle, facial features and general deportment are remarka-bly close to a study in one of the artist's note-books and a drawing now in Rotterdam, both of which have been associated with Marie Lucie Millaudon[4]. Mme Millaudon belonged to a plantation-owning family in New Orleans and was a friend of Degas' relatives in America. She visited Paris in 1867 and it was probably on this occasion that the Tate 'Head of a Woman' was executed.

1. Disderi, *Carte-de-visite* photograph of
the Prince and Princesse de Metternich,
c1860

4. *Princess Pauline de Metternich*
c1865
Oil on canvas
400 × 288 mm
Trustees of the National Gallery

Degas painted several of his aristocratic female relatives and a number of distinguished women from Parisian society. None of them, however, was as glamorous or as celebrated as the Princess Pauline de Metternich, wife of the Austrian Ambassador to the court of the Emperor Napoleon III. The Princess delighted in the cultural life of Second Empire Paris and was painted by artists as diverse as Winterhalter and Boudin[1]. It has long been known that Degas' portrait of the Princess was painted from a photograph (fig 1) and it has been assumed that, as an unknown young artist, he would have had no direct contact with the model[2]. However, Princess Pauline's husband, Richard de Metternich, was a prominent member of the exclusive Jockey Club, which dominated not only horse-racing but also the Opéra (where ballets were performed)[3]. By the mid-1860s Degas had already begun to frequent race-tracks and had painted his first pictures of the ballet, so the probability that he would have encountered the Princess, if only at a distance, thus becomes significant.

The existence of a photograph showing the same model as the painted portrait gives us a rare opportunity to study Degas' treatment of a specific woman's appearance. Apart from removing Richard de Metternich altogether, the artist initially introduced a floral wall-paper background and modified some of the detail in the Princess' outfit. In his handling of the face, Degas softened and glamourised the features, suppressing the rather prominent mouth which is evident in both the photograph and the Winterhalter portrait. The presence of such hazy or unfocussed passages of paint in Degas' pictures was once taken as evidence of their 'unfinished' state, but everything about this elegant little picture suggests a deliberate and controlled final result[4].

Most conspicuous of all, however, is the startling colour-scheme which the artist has contrived for what was originally a black-and-white image. The yellow of the woman's bodice, the warm tones of her face and the golds and ochres of the wall-paper combine to create a remarkably sensuous and dramatic visual ensemble. In spatial terms, the flat pattern and the strong colour of the background tend to thrust the figure of the Princess forward, while the rich textures of the paint surface further accentuate her immediacy and proximity. Centrally placed but demurely averting her glance, the Princess maintains her poise while showing none of the coquettishness of the Winterhalter portrait or the formality of the original photograph.

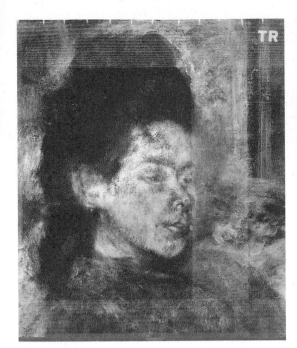

2. X-ray photograph of Degas' 'Elena Carafa'.

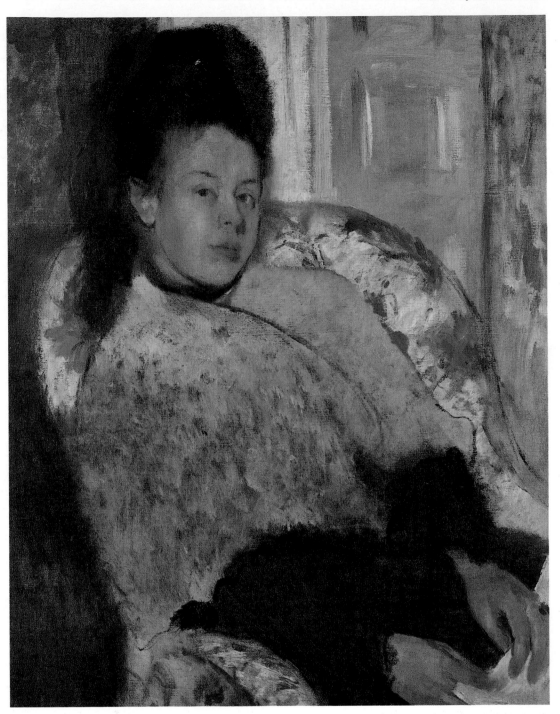

5. *Elena Carafa*
1875
Oil on canvas
698 × 546 mm
Trustees of the National Gallery

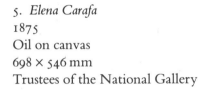

Elena Carafa was Degas' cousin[1]. She was the daughter of his father's youngest sister, Stefanina, the Duchessa Montejasi-Cicerale, and was more than twenty years younger than the artist. In this portrait Degas shows her at ease in a comfortable apartment, either on a visit to Paris or in the family Palazzo in her native Naples. Everything is contrived to suggest relaxation, from the warm colours of the upholstery to the undulating rhythms and rounded forms of armchair, shoulders and face. Elena leans back casually, her off-centre head and diagonally inclined body almost a mockery of the traditional posed portrait. At the lowest point of this diagonal, her hands hold a book or magazine, a single finger left between the pages to mark the point where her reading has just been interrupted. This sense of a captured moment, of a gentle intrusion into a moment of privacy, is continued in the inclination of Elena's head and the rather unwelcoming expression on her face. The intrusion causes no alarm, however, since the considerable intimacy of our view-point is met only with a reciprocal gaze and a still open and relaxed body position. By implication, Elena confronts a social equal or a family friend, whose close proximity is acknowledged but not at this moment encouraged.

Degas painted Elena on at least two other occasions, in each case in the company of her sister Camilla and in one example with their formidable mother, the Duchessa[2]. In comparison with these other portraits, Elena appears here informally attired and unadorned by jewellery or other accessories. At about the time this picture was painted, the family was obliged to wear mourning on more than one occasion and this may explain the predominantly black colour of the sitter's outfit[3]. Close examination of the canvas shows that the upper part of Elena's costume was also originally black, the blue-grey shawl having been superimposed by the artist as one of a number of later changes to the composition. Her left shoulder was once lower and less sharply angled and, even more tellingly, her face originally looked in a different direction. X-rays have shown that the head was both tilted further back and angled more towards the right-hand side of the picture (fig 2), giving extra significance to the artist's final decision to turn the sitter to meet our gaze.

6. *Hélène Rouart in her Father's Study*
c1886
Oil on canvas
1610 × 1200 mm
Trustees of the National Gallery

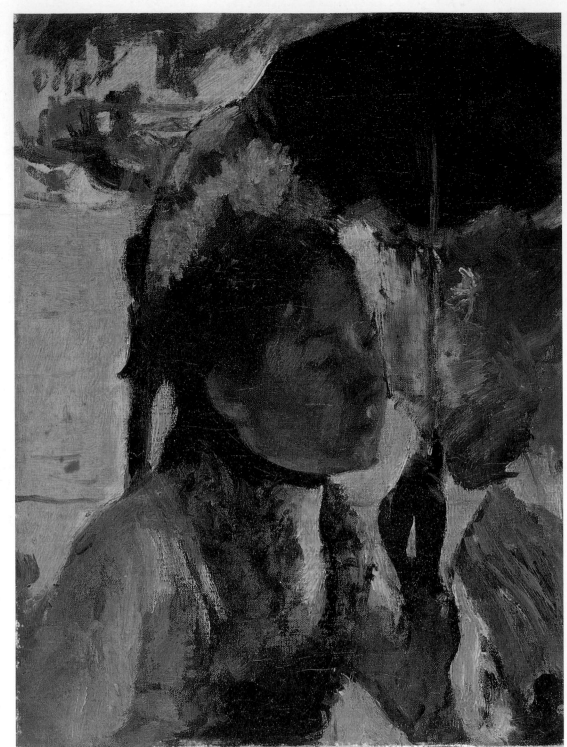

7. *At the Tuileries*
c 1880
Oil on canvas
270 × 200 mm
The Burrell Collection, Glasgow Museums
and Art Galleries

Degas' pictures of women in the open air or in public spaces generally follow a different set of conventions from his portraits and domestic scenes. In keeping with the behavioural codes of his day, women of his own class are depicted either at a physical distance or without the presumption of intimacy. Eye-contact is rarely established and when the scale of the painting and our implied vantage point suggest proximity (as in the present example), it is the proximity of the passer-by or even the furtive devotee of the field-glasses. The model for 'At the Tuileries' is unknown and the picture itself provides few clues to the original context of the scene, though a little persistence will transform the blur in the top left-hand corner into a distant horse-drawn carriage. The painting was given or sold to Degas' friend Michel Manzi and the present title may therefore be the artist's own, indicating a setting in the fashionable Jardin des Tuileries in central Paris[1]. Elaborately dressed and coiffeured, the woman in 'At the Tuileries' is clearly on display, her tastefully co-ordinated hat, gloves, dress and parasol declaring her sophistication while precisely distancing her from the gaudy street-walker or the over-dressed shop-girl.

Such images of fashionable women in public were widespread in Degas' world, often showing the same kind of miniscule parasol and obligatory female companion that occur in 'At the Tuileries'. This elegant follower of fashion became almost a cipher, a quintessential emblem of female inactivity and passive ornamentation who haunts the pages of fashion magazines and the paintings of Degas' contemporaries from Courbet and Manet to Boudin and Monet. Whether at the race-track, on the beach or in a public park, the correctly caparisoned female with her armoury of accessories ensured the prosperity of the couturier, the milliner and the department-store owner. In 'At the Tuileries', Degas left the finer details of the woman's costume and the full glamour of her *ensemble* to the imagination of the viewer. The artist's decision to depict her face in shadow, to crop away everything but her head and shoulders, and above all to render this elegant scene in dense smears of oil-paint, reminds us how often Degas inverted, or distanced himself from, prevailing conventions of representation.

8. *The Actress Ellen Andrée*
c1879
Drypoint
113 × 79 mm
Josefowitz Collection

The critic Arséne Alexandre, who had known Degas personally, described the subject of this print as; 'a young woman, standing, in a jacket and a 'Niniche' hat, her nose in the air, her hair in a mess. In several scribbles, Degas has evoked no more, no less that the charming Ellen Andrée who, by her urchin-like grace, her heady and light Parisian touch, illuminated the small group of Halévy, Degas, Meilhac, Renoir and *tutti quanti*. It is only a little nothing, but a perfect, exquisite nothing'[1]. Alexandre's statement was made almost forty years after the drypoint was executed, but his identification of its subject has been generally accepted[2]. Ellen Andrée was an actress who also posed for her artist friends, most famously as one of the drinkers in Degas' 'L'Absinthe' and the sensational nude in the painting 'Rolla' by Degas' friend Henri Gervex. She was one of a number of well-known women from the world of the theatre and the opera whom Degas knew personally, several of whom he portrayed in portraits, stage scenes and even sculptures. There is no suggestion that these images were commissioned by the celebrities themselves, so we must assume that they posed for Degas in his studio or that he worked from the small black-and-white photographs of popular entertainers that were widely available at this time (fig 3).

In Degas' drypoint, Ellen Andrée is shown in her street clothes, carrying what appears to be a book in one hand and a parasol in the other, and sporting one of the bizarre hats that frequently seem to accompany her. Though the study is hardly developed as a complete scene, she is depicted as an alert and confident figure, dominating the picture rectangle with an air of independence that is uncommon in images of women at this period. The suggestion that Andrée is outdoors, or even walking through the rooms of a public art gallery, is supported by a series of drawings and pastels by Degas, one of which clearly provided the basis for this drypoint. There is potential confusion in the fact that these drawings include a figure rather like the present Ellen Andrée, but who has traditionally been identified as Mary Cassatt[3]. Somewhat surprisingly, the artist appears to accept the interchangeability of the socially-conscious Cassatt and the 'urchin-like' Andreé, a rare example of class confusion in Degas' work.

3. Nadar, 'Ellen Andrée', 1879.

4. Bertall, from 'La Comédie de notre temps', 1875.

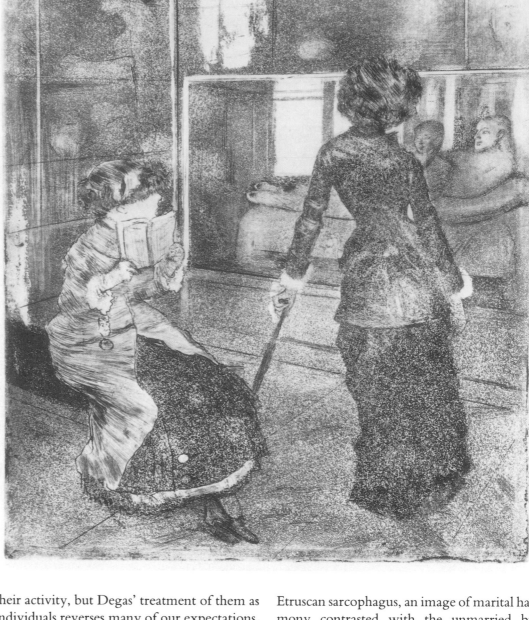

9. *Mary Cassatt at the Louvre*
1879–80
Etching, aquatint and electric crayon
267 × 232 mm
Josefowitz Collection

This is the most precisely documented and widely discussed of all Degas' prints, as well as being one of his most celebrated representations of women[1]. It is also an image that Degas himself attached particular importance to, choosing it for public exhibition and possible publication, and returning to its central subject on a number of occasions for other works in etching, pastel and oil. It has long been known that the etching shows the American painter Mary Cassatt with her sister Lydia, and Cassatt herself recorded that she posed for the standing figure at the right[2].

Apart from its historical and technical significance, this is also one of the most audacious images of the opposite sex that Degas ever produced. When representing working-class women, whether they were ballet-dancers, laundresses or prostitutes, Degas took considerable liberties in composition and with his own implied view-point. With women of his own class, on the other hand, his approach is almost invariably more decorous. The prosperous and 'respectable' nature of the two women in this etching is spelt out in their costumes, their deportment and the nature of

their activity, but Degas' treatment of them as individuals reverses many of our expectations. Lydia is the more orthodox of the two, but even here Degas surprises us by half-concealing her face behind a catalogue and a scarcely-flattering hat. The depiction of Mary Cassatt, however, with her back turned firmly towards us and her face entirely hidden, is utterly unconventional. While it may be true that Degas was putting into practice his friend Duranty's claim that 'a back should reveal temperament, age, and social standing', his decision to subject the dignified Cassatt to this treatment suggests either impertinence or exceptional familiarity[3]. That Degas did have a close and even playful relationship with Cassatt, and that he was intentionally subverting a number of standard conventions of representation, is pursuasively argued in an essay by Richard Thomson[4]. Thomson points to the cliche current amongst illustrators and painters which showed women in art galleries as unresponsive to the works of art on display (fig 4), and also emphasises the irony of applying such a cliche to the erudite Cassatt. Irony is also present in Degas' depiction of the

Etruscan sarcophagus, an image of marital harmony contrasted with the unmarried but highly eligible pair of young American visitors.

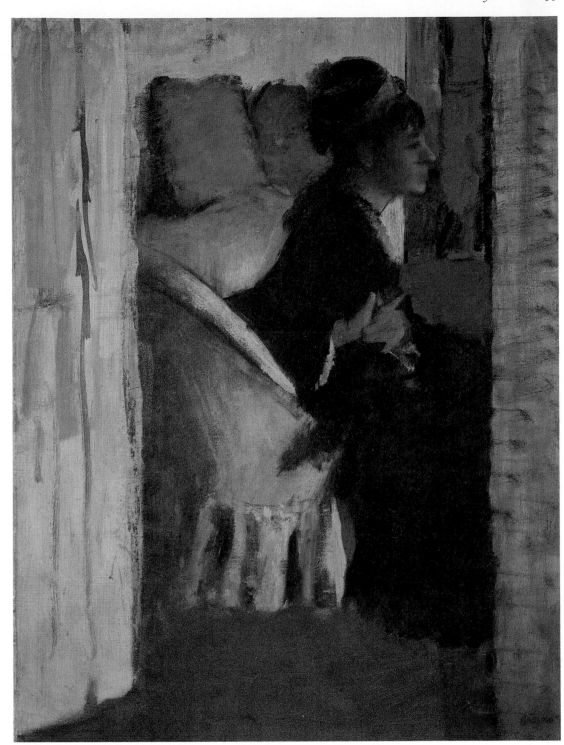

10. *Woman Putting on her Gloves*
c1879
Oil on canvas
635 × 483 mm
Private Collection

In the 1870s, Degas produced a large number of pictures of women from his own social circle, often portraying them in surroundings that reflect their class or characteristic activity. This was the period when Degas' interest in what had been called 'Scientific Realism' was at its height and when his own studies of contemporary society took on a quasi-systematic pretension[1]. Apart from depicting a wide range of different social categories and human types, Degas also delighted in recording the finer points of their behaviour, costume and bodily deportment. The idea that an individual's environment and behaviour could communicate much about their personality was commonplace in contemporary literature, and the novelist Emile Duranty, who was painted by Degas at this time, argued for a similar approach in the visual arts. 'Woman Putting On her Gloves' could almost be an illustration of the writer's argument. Duranty specified that the person depicted at rest 'will not be merely pausing or striking a meaningless pose before the photographer's lens. This moment will be a part of his life as are his

actions'; he also notes that 'a gesture should reveal an entire range of feelings' and suggests that a pair of hands can define social status[2]. Some phrases from Duranty's text fit the picture almost uncannily; we read that our viewpoint may mean that 'furniture is abruptly cropped' or that the figure 'appears cut off at the knee or mid-torso'; and that 'Our peripheral vision is restricted at a certain distance from us, as if limited by a frame'[3].

The woman glimpsed through the open door sits alertly on the edge of a low easy-chair, her rather tense pose and outdoor costume suggesting the paying of a social call. An anecdote recorded by Paul Valéry describes how Degas once imitated a woman in a similar situation, as she nervously rearranged her costume and pulled her gloves tightly over her hands, and everything about 'Woman Putting On her Gloves' point to the precise recreation

of such a specific domestic event[4]. A slight blurring in the paint of the hands and face increases the sense of an occasion captured, and the woman's averted gaze and the surrounding door-frame suggest a private encounter from which the viewer is excluded. Despite the precision of the image, the identity of the sitter in 'Woman Putting On her Gloves' is not recorded. However, the startling resemblance between the woman's costume and pose and that of the seated figure in 'Mary Cassatt at the Louvre' (cat 9), and to other images of the two Cassatt sisters, may suggest that this is another image of the two women who Degas so openly admired.

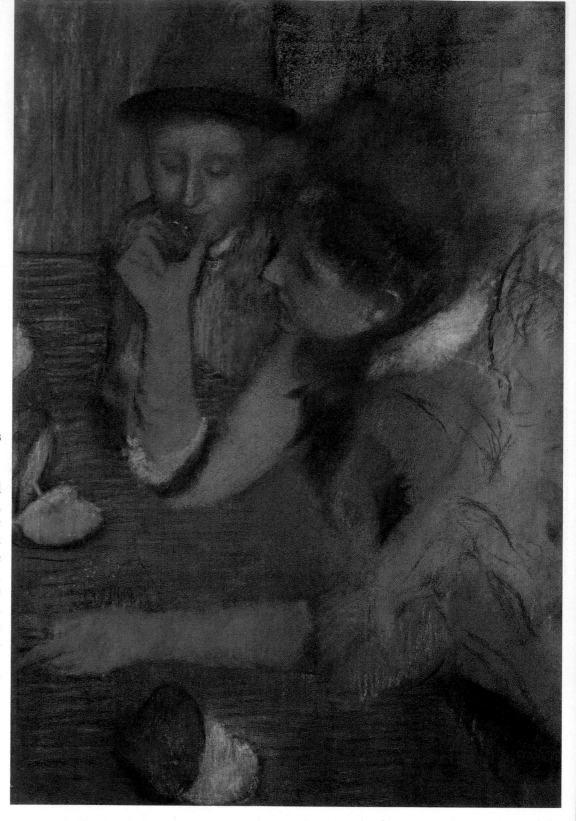

11. *The Jewels*
c1887
Pastel
720 × 490 mm
The Burrell Collection, Glasgow Museums and Art Galleries

As part of his project to document the social domestic world of contemporary women, Degas produced a series of images which show the leisure activities of his female friends and acquaintances. His pictures of women at the race-track and the art-gallery are well-known, as are his studies of the theatre and the public park. At a more intimate level, Degas depicted women with their families and children, scenes of idle gossip and trips with friends to hat-shops and couturiers. 'The Jewels' clearly belongs to this series, the women's outdoor clothes and the range of jewellery-cases on display indicating a visit to a fashionable shop on the boulevards of Paris. This particular subject is highly unusual, perhaps unique, in Degas' work, but it is known that the artist often accompanied his female friends on their shopping expeditions and delighted in their costumes and their colourful surroundings.

'The Jewels' is characteristic of Degas' images of women in another important respect. The foreground figure, like so many prominent subjects in the artist's work, is engaged in the act of looking[1]. Here she gazes attentively, even avariciously, at a richly encrusted bracelet or brooch, her whole body polarised around the axis of her vision. In other drawings, pastels, prints and paintings Degas shows women staring into mirrors, peering through binoculars, contemplating works of art, coveting be-ribboned hats and gazing down from theatre boxes. The look can be narcissistic or flirtatious, intimate or distancing, but it is always the defining function of the woman's activity or perhaps, more precisely, her inactivity and powerlessness. In all the occupations described, the woman is involved in an inessential or cosmetic endeavour, grooming herself for the attention of others and exercising her only influence through the time-honoured medium of the gaze[2].

The identities of the two women in 'The Jewels' are unknown, though the Lemoisne catalogue associates the picture with a group of female portraits of approximately the same date[3]. Degas was an acute and not entirely solemn observer of the woman's hat, and the conical specimen worn by the more distant woman, as well as the general cast of her facial features, appear to coincide with a pastel of the same date that has recently been identified as the distinguished ballet-dancer Rosita Mauri[4]. In discussing this latter portrait, Gary Tinterow suggests that the woman's animated arms and body, which are not unlike the figures in 'The Jewels', owe something to contemporary theories of pictorial dynamism[5]. Whatever the original context of the Burrell pastel, Degas seems to have left it unfinished or reworked part of the woman's dress at the right.

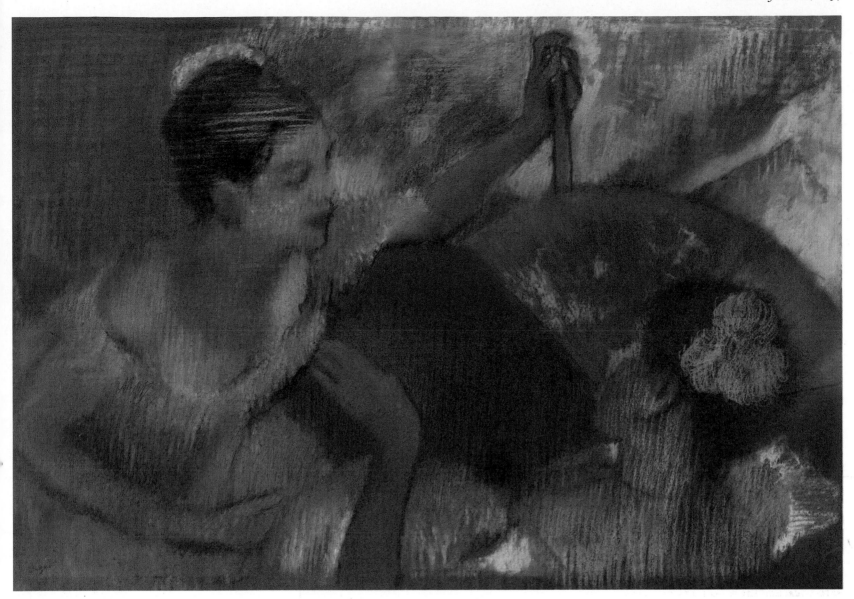

12. *The Theatre Box (Dancers in a Box)*
c1885–90
Pastel on paper
620 × 870 mm
The Burrell Collection, Glasgow Museums
and Art Galleries

Most of the titles associated with Degas' drawings and paintings today were not given to the works by the artist himself. This large and richly worked pastel has for many years been known as 'Dancers in a Box', but this is surely misleading[1]. A careful examination of the image, its documented history and its relationship to Degas' own codes of representation, leaves little doubt that we are looking not at ballet dancers, but at two fashionably dressed women. Although the densely textured pastel surface creates a certain ambiguity in the image, the red areas clearly represent the sides and front of the box itself, while the top right-hand corner shows a glimpse of the stage beneath. What is more, a dancer is just visible on this stage and it is evident that a performance is taking place or has just finished (the dancer may be taking a bow). A group of drawings, pastels and prints based on a very similar setting suggests that Degas had a particular interest in this subject, producing a number of variation on the female figures, their fans (both open and closed, as in this example) and the dancers below[2]. In these works the costumes of the protagonists and their social identities are more precisely defined, and the sheer improbability of two dancers watching a ballet from a box is underlined.

The ambiguity of 'The Theatre Box' is not without significance. Though the women are evidently visitors to the theatre rather than performers, the way in which they have been represented is at first sight unexpected. Such close-up views of middle-class women are widespread in Degas' work (as in 'At the Tuileries' (cat 7) and 'The Jewels' (cat 11)) but the dramatically elevated view-point is normally reserved for humbler or more familiar subject-matter. Several of Degas' contemporaries made pictures of such groups at the theatre and it is noticeable that the men in the party consistently stand behind, and often above, their female companions. More than one writer has noted that Degas' vertiginous views from theatre boxes presuppose a male point of view, a possibility supported by the artist's witty play with opera glasses and bare female shoulders in several of the picture variants. None of these observations, however, explains the unusually indecorous behaviour of the women in 'The Theatre Box'. Degas' depiction of 'society women' almost invariably respects the reserve and decorum of their class, but the flailing arms, animated conversation and complete disregard of the stage performance (the right-hand figure's fan obliterates her view of the proceedings) shown here contrasts sharply with the well-mannered theatre pictures of Renoir and Cassatt, as well as others by Degas himself[3]. Historically, of course, the theatre box was the scene of much unconventional behaviour, and this image is exceptional only in its departure from the artist's own self-imposed codes of practice.

Degas was an individual with a strong sense of class identity. He came from a privileged background and had aristocratic relatives on his father's side, and many of the attitudes and assumptions of his upbringing stayed with him throughout his life. His own career in the arts brought him into contact with the widest possible range of Parisian society, but Degas stood aloof from bohemianism and maintained the proprieties of his class. Like his friend Manet, Degas chose to wear the formal top hat and attire of the *haut bourgeois*, and would mix with respected 'establishment' artists as well as with his Impressionist colleagues. Degas' relationships with friends, fellow-professionals, servants and models all suggest a clearly defined and essentially orthodox sense of class division. Later in life, Degas became more conservative and dogmatic than ever, railing against calls for social equality and even recalling the old days 'when everyone stayed in his place and dressed according to his station'[1].

In spite of, or perhaps because of, his social background, Degas dedicated a large part of his career to the depiction of the working women of Paris (with the exception of jockeys, the working men of the city hardly appear in his work). The laundresses, milliners, entertainers and prostitutes in his pictures were the women who serviced his social group, and Degas set about their documentation with an almost exemplary rigour. A number of anecdotes survive which illustrate something of Degas' attitude to his chosen subjects. In 1891 he observed; 'I love to see the families of the working-men in the Marais. You go into these wretched-looking houses with great, wide doors, and you find bright rooms, meticulously clean . . . everybody is lively; everybody is working. And these people have none of the servility of a merchant in his shop[2].' He expressed a patrician concern for the dancers who posed for him, noting that 'most of them are poor girls doing a very demanding job . . . who find it very difficult to make ends meet'[3]. Degas also had a reputation for correct behaviour in front of his studio models, on one occasion apologising for a sudden outburst of bad language[4]. These and other instances suggest both a fascination with, and a calculated distance from, his working class subjects, a combination of participation and detachment that was to become a hallmark of Degas' art.

Degas was not, of course, alone in his preoccupation with working-class subject-matter.

Manet's barmaids, Morisot's wet-nurses, Raffaelli's rag-pickers and Pissarro's rural harvesters all extend the catalogue of contemporary female occupations, but none of these artists committed themselves so exhaustively to the objects of their interest. Closer comparisons may perhaps be found amongst the writers of the day, with Zola's novels based on laundresses and shop-girls or the Goncourts' studies of house-maids and prostitutes. Most of these artists and writers worked for predominantly middle-class patrons and readers, and presumably something of their choice of subject-matter can be explained by a bourgeois fascination with the lower orders or the picturesque poor. It is also significant that a number of Degas' artistic acquaintances, such as Tissot, Béraud and Boldini, were specifically identified with the opposite tendency in contemporary painting, specialising in glamorous women and scenes of social refinement. By distancing himself from this company and identifying with the school of Realist authors and painters, Degas implicitly accepted something of the changing direction of contemporary society. As recent research has demonstrated, Degas aligned himself to some extent with the scientific spirit of the age and may, at certain points in his career, have shown sympathy towards supporters of the rising Feminist movement[5]. His pictures of working woment are scrupulous, perceptive and rarely disrespectful; though he does not idealise his models, he pays them the compliment of extended and considered attention, and rarely subjects them to caricature.

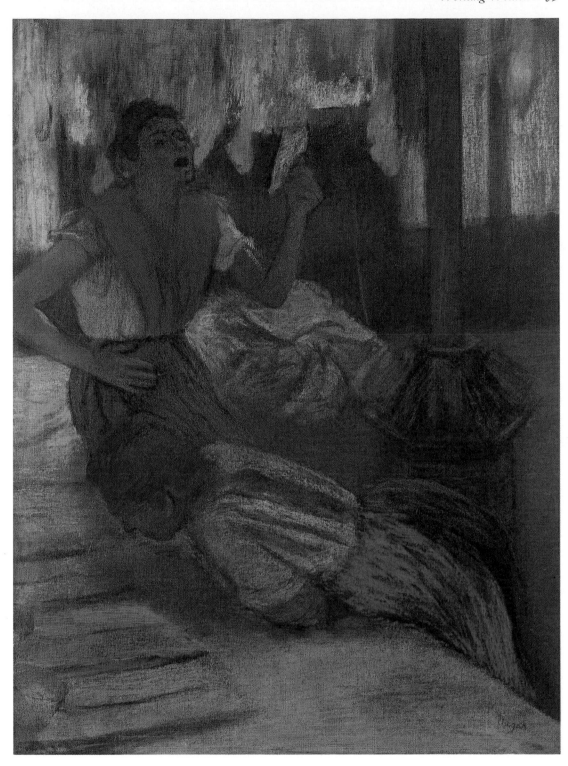

13. *Reading the Letter*
c1884
Pastel on paper
630 × 450 mm
The Burrell Collection, Glasgow Museums
and Art Galleries

Degas' images of laundresses are some of his
most well-known works of art, yet they form
one of the smallest groups amongst his
'modern life' pictures. Only about ten finished
paintings or pastels of the subject exist, with
approximately the same number of prepara-
tory drawings, but there is evidence that Degas
himself attached particular importance to
them. On four of the seven occasions that he
participated in the Impressionist exhibitions,
Degas chose to exhibit pictures of laundresses
(including five examples in 1876), and he con-
tinued to return to the subject over a twenty
year period. His laundress studies were also
popular with his contemporaries, the majority
of the finished examples finding buyers during
the artist's life-time[1]. The reasons for their
popularity are far from clear, since they rep-
resent the most explicit treatment of hard
physical labour in squalid surroundings to be
found in Degas' work. However, as Theodore
Reff, Eunice Lipton and others have pointed
out, the laundress was a familiar figure in the
literature and popular imagery of Degas' time,

and his treatment of the subject must be seen
against this established language of form and
meaning[2].

'Reading the Letter' is unlike Degas' other
laundress pictures in a number of important
respects. It is one of only two versions of the
subject in pastel, and it is amongst the smallest
of the series[3]. More importantly, it is unique in
representing the two laundresses at rest, rather
than in the process of ironing. Even the com-
position, with the strong diagonal of the table-
top and the detailed depiction of the room in
which the women are working, is distinct
from the rest of the group, suggesting that
'Reading the Letter' may have been an exper-
imental variant that the artist decided not to
pursue. This version places particular emphasis
on the exhaustion of the laundresses and on the
nature of their labour; Degas has set out in an

almost documentary way the sequence of
operations involved in the laundry, from the
heap of soiled clothes on the floor and the wet
washing on the line, to the glowing stove
where the irons were heated and the finished
piles of pressed shirts. Even the sheet of paper
held by the principal figure, which has tra-
ditionally been seen as a letter, is as likely to be a
laundry list.

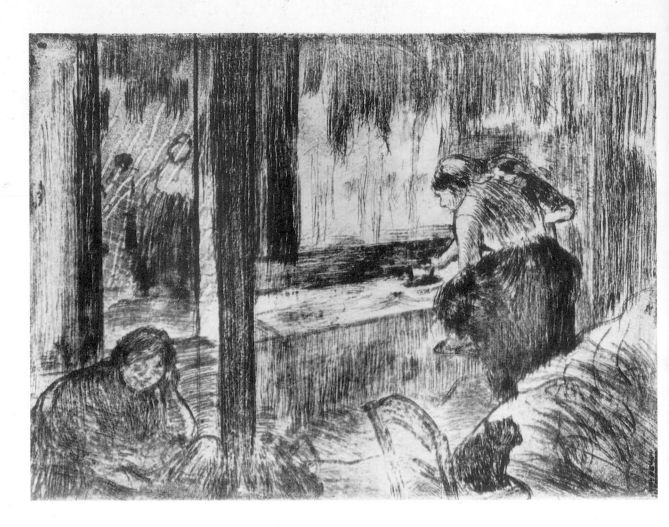

14. *The Laundresses*
c1879–80
Etching and aquatint
118 × 160 mm
Josefowitz Collection

Of all Degas' representations of laundresses, this small etching comes closest to depicting the harsh reality of their daily lives. Its dull grey tones, heavily textured surface and crowded, even claustrophobic composition give powerful expression to the grim working conditions of the laundresses' trade. In Degas' time, the laundry industry was a conspicuous feature of Parisian life, employing enormous numbers of women to collect, wash and iron, and return the clothes of the better-off[1]. Rates of pay were minimal, working hours were long and the laundries themselves were often situated in the poorest streets and dampest basements. The activity of the laundry required that wet washing should constantly be hung up to dry and a blazing stove was needed to heat the flat-irons, resulting in a hot, humid atmosphere that notoriously led to illness and a low life-expectancy. Given this background, the reactions of some writers to Degas' laundry scenes, in which admiration is expressed for the nobility of the female protagonists and the delicacy of the light effects, seem out of place in the context of this etching. In some of his laundress paintings, Degas did draw attention to the figures of the women and away from their insanitary surroundings, but this etching is unique in its emphasis on the dank atmosphere of the laundress' environment. In this respect, 'The Laundresses' aligns itself with Zola's celebrated novel *L'Assommoir* (which it may be intended to illustrate) and lies at the opposite extreme to the rural laundress tradition, such as Boudin's 'Laveuses au bord l'eau' (fig 5)[2].

This is the only etching that Degas devoted to the subject of the laundry, though there is a large monotype of about the same date with a number of similar features[3]. Typically, Degas reworked the etching plate and four states of the image have been identified[4]. Using several technical processes, the artist built up a variety of surface effects to evoke the textures and tones of an ill-lit workshop, skilfully integrating a number of spatial planes and subsidiary centres of interest. As in the pastel 'Reading the Letter', Degas spelt out the entire range of the laundress' activities, from the pile of unwashed clothes to the final process of ironing, though here we can make out more clearly the irons being heated on the stove and a distant glimpse of passers-by in the street. The pose of the laundress who adjusts her slipper is not easily explained, though a more homely note is suggested in the jovial figure beside the stove and the presence of the laundry cat.

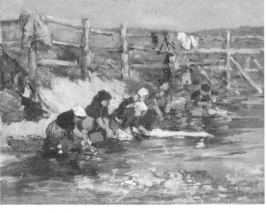

5. Boudin, 'Washerwomen beside the water', National Gallery.

15. *Woman Ironing*
c1892
Oil on canvas
800 × 635 mm
Trustees of the National Museums and Galleries on Merseyside (Walker Art Gallery)

It has recently been proposed that 'Woman Ironing' represents a final return by Degas to the theme of the laundress, some twenty years after he had exhibited his first study of the subject[1]. Paradoxically, both the composition and the pose in 'Woman Ironing' resemble this first version more closely than that of any of the intervening variants, as if the artist were returning nostalgically to his earliest conception of the subject. When the earlier version was shown in public, one critic expressed his distaste for the dark silhouette of the laundress and another pointed out that the clothes she was ironing still appeared to be dirty[2]. Subsequent discussion of the laundress pictures has been almost as diverse, ranging from a rather simplistic celebration of their colours and light effects to a more recent emphasis on their social context. It has been pointed out that laundresses were poorly paid, that they worked in grim conditions and often ended up as alcoholics. References to all these circumstances can be found in Degas' pictures, but his attitude to another aspect of the laundress' reputation, their sexual availability, is more open to contention.

As Eunice Lipton has shown, the figure of the laundress in nineteenth-century France was widely associated with flirtatiousness and casual prostitution[3]. A variety of contemporary paintings depict pretty young women standing at their ironing boards or coquettishly engaged in conversation with male customers, while similar scenes appeared in stage-plays, caricatures and magazine illustrations. Much of this popular imagery makes pointed and quite unambiguous reference to the attractiveness and sexuality of the laundress, often through such devices as the exposed cleavage or the half-open chemise. Degas, on the other hand, specifically distanced himself from these conventions in the great majority of his laundress pictures. He pointedly omitted men from his compositions and avoided all suggestion of narrative where more than one figure is present[4]. Degas' laundresses, as in the canvas from the Walker Art Gallery, are substantial working women involved in hard physical labour, quite unlike the simpering adolescents who affect an ironing posture in more popular imagery. Though Degas does show bare arms and occasionally shoulders (laundresses wore notoriously scanty clothing in their hot working conditions), he never emphasises their breasts and avoids the suggestive glance[5]. As in a number of Degas' modern life subjects, it is his questioning of conventional modes of representation, rather than his reiteration of them, that distinguishes his work.

16. *Miss Lala at the Cirque Fernando*
1879
Pastel on paper
610 × 476 mm
Trustees of the Tate Gallery

Many of Degas' pictures of working women, such as dancers, laundresses and this circus performer, show his subjects engaged in disciplined and strenuous physical activity. There is evidence to suggest that Degas, who was one of the most dedicated and hard-working artists of his generation, identified with their labours and was able to express a certain respect for them in his pictures. We know that Degas studied the techniques and the terminology of ironing when he worked on his laundress paintings and that he frequented the rehearsal rooms of the ballet and could demonstrate the dancers' steps. He also had an unexpected taste for popular entertainments, such as the Café-Concert and the circus, and based a number of elaborately constructed pictures on his favourite entertainers. 'Miss Lala at the Cirque Fernando' is one of a sequence of drawings and pastels, many of which were apparently executed on the spot, made in preparation for a finished oil painting now in the National Gallery. The object of Degas' interest was a mulatto acrobat known as Miss Lala (who subsequently performed at the Crystal Palace in

London) whose star turn involved being hoisted to the roof suspended by her teeth[1].

Miss Lala is shown at a moment of intense exertion, but also in a state of equilibrium. It has often been observed that we see the pirouetting acrobat from beneath, but not, perhaps more importantly, that we also view her from an unnaturally close vantage point. Such proximity suggest the use of opera glasses or binoculars, and also implies a presumptious intimacy with the woman's body that was fraught with significance in the late nineteenth century. Characteristically, Degas has only chosen to take this liberty with a woman of inferior social status and it is perhaps significant that such low view-points occur very rarely in his work, despite his declared interest in their pictorial possibilities[2]. Circus imagery appears in one or two of the novels that chronicle the seamier side of contemporary life, but Degas himself only returned to it for one lithograph

of the circus ring[3]. Theodore Reff has pointed out that Degas, who always liked to upset the expectations of his listeners, insisted on the *artificiality* and not the realism of his imagery, saying to a landscape painter on one of his visits to the Cirque Fernando; 'for you natural life is necessary; for me, artifical life'[4].

17. *Singer at a Café-Concert*
c1876–7
Lithograph on paper
345 × 270 mm
Trustees of the British Museum

The identity of this scene and the significance of its composition are not, at first sight, easy to decipher. By reference to other works by Degas we can deduce that the figure is a cabaret singer, apparently standing at the edge of a stage and gesturing towards an unseen audience at the left. The setting appears to be an open-air cabaret or Café-Concert, with a striped awning above the singer's head and some evidence of the stage itself behind her[1]. A glimpse of an illuminated gas-globe behind the strut of the awning reminds us of Degas' more well-known cabaret scenes, while emphasising the extent to which the legibility of this particular image relies on informed deduction. In virtually all of Degas' other pastels, prints and gouaches of the subject, he locates us clearly in the structure of the Café-Concert, usually within the audience but otherwise with some clear reference to the orchestra, decor or proscenium surround. In 'Singer at a Café-Concert', the overwhelming question is that of our implied view-point. Where are we? If, as seems to be the case, we are above and behind the performer, why are we there? Such an elevated vantage-point is hardly flattering to the singer and results in a partly obliterated face, reversing the normal experience of the audience at the front of the stage. Perhaps exploiting his privileged access to the back-stage area or simply attracted by the novelty of a bird'-eye view, Degas has produced one of his most inscrutable and ambiguous images of a woman at her professional task.[2].

The Café-Concert was a popular and controversial entertainment in Degas' Paris. At its humblest level it was no more than a bar with a stage at one end, while the more luxurious establishments in the Champs Elysées boasted ornate pavilions, outdoor seating and a substantial orchestra. Customers from a wide variety of social backgrounds could watch the performance for the price of a drink, listening to comedians or vocalists such as the figure in 'Singer at a Café-Concert'. As T J Clark has pointed out, even the most glamorous Café-Concerts were seen as unacceptably vulgar by polite society, and there were government controls to limit the nature of the entertainment on offer[3]. In spite of censorship, the performance continued to feature suggestive comic routines and politically subversive songs, presented by both male and female performers (Degas chose to concentrate exclusively on the latter)[4]. Many of his pictures show a first-hand familiarity with the brash decor and heterogeneous clientele of the Café-Concerts, though in 'Singer at a Café-Concert' Degas has opted for delicacy and imprecision.

18. *The Customer*
c1876–7
Monotype on Chinese paper
220 × 164 mm
Musée Picasso, Paris

There has been considerable coyness in the past about Degas' scenes of the brothel and even more about his own familiarity with such establishments. It can now be shown that Degas himself, in common with many of the the men of his class, made use of brothels and we can assume that his images of prostitutes and their clients were based on first-hand experience[1]. Several writers have stressed the prominent role of prostitution in late nineteenth-century Paris and it is clear that public debate and political controversy surrounded the issue[2]. It has also been pointed out that a number of authors known personally to Degas published much-discussed novels about the subject in the mid-1870s, at the time when the artist was working on his own sequence of brothel monotypes[3]. Degas himself evidently read at least one of these books, since he inscribed the words 'La Fille Elisa' (the title of a story published in 1877 by Edmond de Goncourt) on certain of his note-book drawings[4]. *La Fille Elisa* is instructive in this context, since it describes the progress of a young Parisienne through several different levels of prostitution before her eventual downfall. Elisa initially chose prostitution as an alternative to the squalor of her life in Paris, becoming the star attraction in a comfortable provincial brothel. As her fortunes and her good looks declined, Elisa worked as a virtual streetwalker and ended up in an insalubrious establishment used by the Paris military (this is the sequence illustrated in Degas' sketchbook). Though some of Degas' monotypes appear to be based on more luxurious brothels than those described in *La Fille Elisa*, a number of Goncourt's descriptions of rooms, clientele and the girls themselves correspond closely to the artist's work.

'The Customer' shows the mirrored walls, upholstered benches and scantily-clad residents described by Goncourt, Huysmans and Maupassant in their respective stories. As in a number of Degas' brothel monotypes, the presence of a male figure removes all ambiguity from the scene and suggests a narrative relationship between the protagonists. The narrative language, spelt out with unusual precision in gestures and facial expressions, might be that of a book illustration, a suggestion reinforced by the small scale and monochrome character of the image. Although no specific text has been found to correspond to 'The Customer' and its associated works, some of Degas' monotypes with less salacious subjects were intended for publication and the dealer Amboise Vollard, soon after Degas' death, used a number of his brothel scenes in an edition of Maupassant's story *La Maison Tellier*. In 'The Customer' we appear to be glimpsing an early sequence from such a narrative, or perhaps a frame from a silent film, where the male client in his street clothes enters the Salon and makes his choice from the *filles*. The prostitutes are shown naked but for stockings and jewellery, the vaunted paleness of their flesh in marked contrast to the dark, contained vertical of the man. This curiously attenuated individual appears in a number of Degas' brothel monotypes and reappears regularly behind the scenes (usually in the process of soliciting the female peformers) in paintings and pastels of the ballet. Almost as much a caricature as the women he confronts, this cipher of calculating masculine lust is at least as unattractive as the docile, over-weight objects of his attention.

Degas only made such explicit images of the brothel in monotype. The monotype technique, which lends itself to small-scale monochrome imagery and thus is easily associated with illustration and even photography, may have seemed a natural medium for such subject-matter, though Degas also used it for ballet and other subjects (often with a superimposed layer of pastel). To make a monotype, the artist draws or paints with slow-drying ink onto a polished metal surface (often, in Degas' day, a discarded photographic plate)[6]. A sheet of paper is placed over the finished drawing, and plate and paper are then run through a press to produce a unique 'print' of the image, reversed by the printing process. Before the final printing stage, various textures can be achieved by dabbing the plate with an inked finger or wiping the surface with a cloth, and several of these techniques can be identified in 'The Customer'. The procedure involved presupposes the use of a studio and we can assume that Degas' images were made from memory, giving them perhaps an added furtiveness. Of all Degas' work, it was the brothel monotypes that were most admired by Picasso, who once owned both 'The Customer' and 'On the Bed' (cat 19).

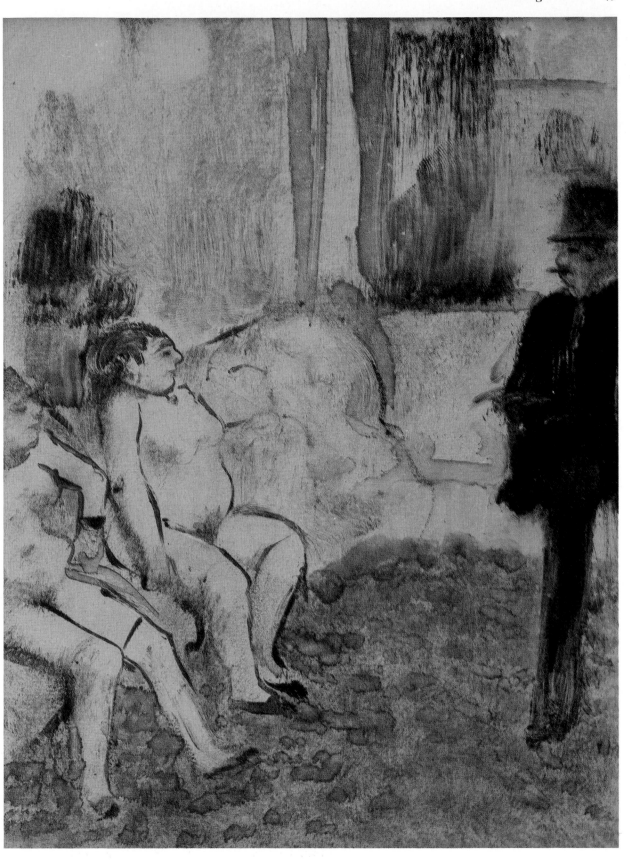

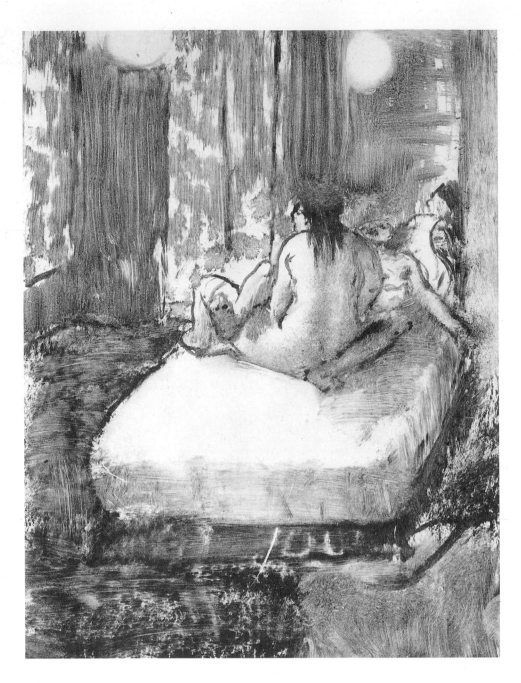

19. *On the Bed*
c1876–7
Monotype on Chinese paper
160 × 117 mm
Musée Picasso, Paris

This is one of the most explicit scenes of love-making in the entire repertoire of Degas' brothel pictures. In literal terms, it represents the culmination of the sequence of events initiated by the scene of 'The Customer' (cat 18), and the fact that its dimensions are identical with a number of related monotypes reinforces the idea of a narrative sequence illustrating a story or a novel[1]. Few images of such intimacy survive in Degas' work, though there is evidence to suggest that others were censored by the artist's brother soon after his death[2]. Although Degas did exhibit a small number of monotypes in his lifetime, they were almost certainly of more innocent-seeming subjects[3]. Images such as 'On the Bed' appear to have been kept in the artist's studio and shown only to a limited circle of friends, in keeping with the long-standing tradition of the gentlmen's after-dinner entertainment. As such, they associate themselves with the conventions of soft pornography as well as the language of voyeurism. Clearly, most of the brothel monotypes presuppose a male audience, but the related question of the viewer's implied role in the picture is given a particular piquancy in 'On the Bed'. In such intimate circumstances, how could the artist be present? Given that the room is lined with mirrors, could it be autobiographical?

It has been argued that Degas' monotypes depicted a sordid and sometimes satirical view of the brothel that was in keeping with establishment attitudes to prostitution[4]. By representing commercialised sex as a necessary but joyless activity, its threat to the stability of family life and thus to the well-being of the state could be minimised. Part of this attitude required that prostitutes be perceived as passive, semi-animal creatures who merely serviced male appetites, and Degas' depiction of them seems to conform to the 'stupified sleepiness' described by Edmond de Goncourt[5]. 'On the Bed', however, fits less clearly into this analysis; the large room, brilliant light and elaborate decor suggest considerable comfort, while the dramatic composition focusses our attention on the dominance of the female figure. Though her left leg is an anatomical improbability, the prostitute's back is reminiscent of the many classically inspired versions of this subject which obsessed Degas in later life.

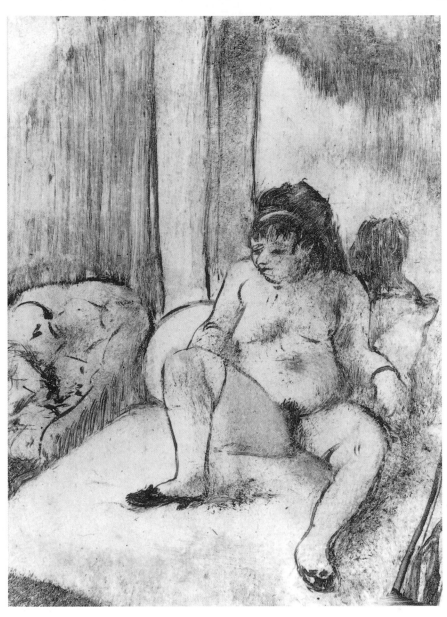

20. *Resting on the Bed*
c1876–7
Monotype
158 × 120 mm
Private Collection

The majority of Degas' brothel monotypes show scenes of lassitude and anticipation, as the prostitutes wait for customers or enjoy the intimacy of each other's company. This poignant image belongs to a small group of plates depicting individual women, alone on a bed and surrounded by the minimal furnishings of their rooms. All our attention is directed at the woman herself, towards her awkward body, her graceless pose and her melancholy countenance. As several writers have pointed out, the weak chin and the low, receding forehead were widely associated by Degas' contemporaries with retarded and probably criminal human types[1]. Degas' repeated use of these characteristics in his figures of prostitutes and ballet dancers is in keeping with this belief, though his tendency towards class caricature is not confined to female models[2]. In 'Resting on the Bed' the woman's nakedness removes many of the normal indicators of class, but her revealed body conforms to the contemporary stereotype of the working-class woman. Her listless, self-absorbed pose and frankly open body position suggest an animal rather than a human sexuality, again in keeping with a number of literary descriptions of the lower-classes. In Guy de Maupassant's *A Woman's Life*, a character is puzzled by the sexual appetites of a friend and observes that 'the Countess did not come of peasant stock, among whom the lower instincts are dominant', while Nana, the heroine of Zola's novel about prostitution, is described as 'giving herself to friends or passers-by, like a good-natured animal'[3].

While the connection between the brothel monotypes and book illustrations has already been noted, their resemblance to black-and-white photographs has never been sufficiently stressed. A small image like 'Resting on the Bed' is similar both in scale and in subject-matter to the large number of erotic photographs in circulation in nineteenth-century France, and the fact that Degas was closely associated with photography and that he re-used photographic plates for his monotypes only strengthens this link. Some of the conventions used in 'Resting on the Bed' are those of the pornographic image, though the model's face is uncharacteristically averted and (like most of Degas' depicted prostitutes) she fails to exchange the viewer's glance. The spectator's position is that of the furtive observer, or perhaps the male customer, a role more explicitly spelt out in some of the artist's other brothel monotypes. Consistent with this view is the model's immodest frontal nudity, which also has the effect of reminding us how rarely this confrontational pose occurs in Degas' art.

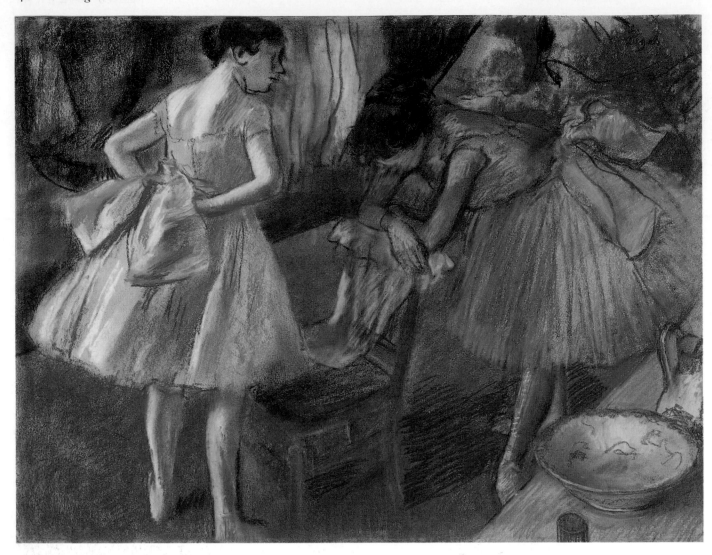

21.

Two Dancers in their Dressing Room
c1880
Pastel on paper
485 mm × 640 mm
The National Gallery of Ireland

More than half the total number of works of art produced by Degas are concerned with the ballet. The reasons for his choice of subject were never spelt out by the artist himself and those attributed to him by his friends are not wholly convincing. On one occasion Degas is supposed to have said 'my chief interest in dancers lies in rendering movement and painting pretty clothes', on another that 'the dancer is nothing but a pretext for drawing', and more than once that dancing reminded him of the Greeks[1]. Degas' early pictures of the ballet, which principally date from the 1870s, were part of a more general interest in the documentation of contemporary life, and they took their place beside his studies of bars, cabarets, laundries and race-meetings. Later in his career, figures of dancers and female nudes became the central preoccupation of Degas' art, often to the point where they became interchangeable. It has often been observed that Degas' principal interest in the ballet was in the back-stage life of the dancers, rather than in their glamorous final perfomances, but it has

yet to be shown just how *systematic* Degas was in his approach to this subject. Shortly before he executed 'Two Dancers in their Dressing Rooms' Degas wrote down in his notebook a detailed list of themes and their variants that he was planning to work on (including some ballet subjects), and there are good reasons to believe that his general approach to the ballet followed such a methodical and comprehensive programme[2].

'Two Dancers in their Dressing Rooms' represents the moment when the members of the *corps de ballet*, having put on their stockings, dancing-shoes and tutus, wait for the call to the stage or idly rearrange their clothing. In hundreds of pastels, paintings and drawings, Degas conducts us through the other moments of the dancers' routine, from the initial toilette in the dressing room to the public performance and its aftermath. We are shown the dressers as they adjust the dancers' outfits, the nervous waiting in the wings and the moment of the star's appearance in the footlights. On stage, Degas turns his attention to the chorus, then the *prima ballerina*, and finally the flourishes at curtain call. After the spectacle, there follow scenes of exhaustion and disrobing, followed (especially in Degas' monoypes) by backstage cavortings and the attentions of admirers. An extensive parallel series also takes the dancer through the procedures of the rehearsal, again building up a

detailed catalogue of individual and group routines. The effect of this major project of documentation is novel-like, almost cinematic, in its progressive and painstaking coverage of a single contemporary phenomenon. It also represents a massive commitment (it is tempting to call it a labour of love) on Degas' part to a subject that clearly fascinated him and commanded his respect. Studies such as 'Two Dancers in their Dressing Room', with their casual poses, high view-points and implied proximity, emphasise the artist's easy familiarity with both the dancers and their world. While Degas hardly glamourises his models, he neither satirises nor belittles them; it should not be forgotten that the same dancers, according to Degas' contemporaries, idolised the artist and flocked round him when he appeared behind the stage.

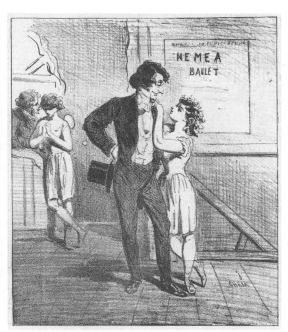

6. Cham, 'La Ballerine', c.1864.
Lithograph.

22. *The Red Ballet Skirts*
c1895–1900
Pastel
813 × 622 mm
The Burrell Collection, Glasgow Museums
and Art Galleries

The dancers in *The Red Ballet Skirts* are not on stage, but waiting in the wings during a performance. Scenes from the wings were a particular favourite with the artist throughout his career, allowing him to depict the dancers in the glory of their stage costumes without the formal demands of choreography, and providing the pretext for a variety of expressive poses and gestures. In this moment off-stage, the *corps de ballet* could abandon its public posturings and rest, stretch and recover. Typically, in this magnificent pastel one figure stands solidly in the foreground, wearily arching her back and neck, while another leans against the scenery and adjusts her slipper. The emphasis is on the mundane reality of the dancers' routine, on the weight and vulnerability of their bodies, and not on the glamour of the unseen stage.

The wings at the theatre were significant in other ways for Degas and his contemporaries. Dancers like those in 'The Red Ballet Skirts' occupied a twilight world where the bright artifice of the performance met the grim reality of back-stage life. In this area, privileged male visitors could watch the performance and mingle with the dancers both during and after the evening's entertainment. Some of Degas' ballet pictures, and a large number of contemporary caricatures (fig 6), spell out the nature of these encounters and leave little doubt that their purpose was as much sexual as cultural. The majority of dancers came from working-class homes and supplemented their income from casual liaisons or by finding a 'protector' amongst the theatre's patrons[1]. In Degas' work, the dancers are approached with the same familiarity and social condescension as his laundresses, milliners and even prostitutes. The figures in 'The Red Ballet Skirts' are shown from close quarters with bare arms, legs, shoulders and backs, and no attempt has been made to individualise their features. Their once detailed faces have been over-laid with almost brutal strokes of pinkish-brown pastel, while their muscular limbs and bodies are typical of the formidable athletes who populate Degas' late dance pictures.

23. *Study of Nuns for 'Ballet Scene from Robert Le Diable'*
1871
Brush and Sepia
280 × 450 mm
The Board of Trustees of the Victoria and Albert Museum, London

24. *Study of Nun for 'Ballet Scene from Robert Le Diable'*
1871
Brush and Sepia
360 × 275 mm
The Board of Trustees of the Victoria and Albert Museum, London

Relatively few of Degas' dance pictures show a performance taking place on stage, and an even smaller number can be identified with a particular ballet that is known to have taken place. In both respects, these two sheets of drawings are exceptional. They show ballet-dancers dressed as nuns, taking part in the graveyard scene from the ballet in Meyerbeer's *Robert le Diable*, an opera that was presented in Paris in 1870 and 1871[1]. Not only do Degas' own notes from the performance and original sketch-book studies survive, but other drawings and two finished oil-paintings of the subject are known[2]. In the original production, the dancer-nuns were seen to rise from their graves, accompanied by ghostly music and dramatic effects of light and shadow. Presumably during the performance, Degas wrote in his note-book; 'the tops of the foot-lights are reflected by the lamps, trees much greyer, mist around the receding arcades – the last nuns more in flannel colour but more indistinct' and 'near the lamp a dancer from behind on her

knees, light falls only on her skirt. The back and the rest in quite deep shadow – striking effect'[3]. In his two oil-paintings of the scene, Degas showed the front area of the stage and part of the orchestra pit, with a brilliantly illuminated strip across the centre of the canvas in which the dancers gyrate. Though the drawings themselves are executed in monochrome, something of the ethereality of the scene is suggested in their wispy brush-strokes and the dancers vacant faces.

Though hardly typical of Degas' dance pictures, these drawings are unusually well documented and historically precise. They also pose a number of questions about Degas' working procedures and his approach to representing the ballet. The broad brush technique of the *Robert Le Diable* drawings is not characteristic of Degas and suggests an improvised, rapid method of execution. Did he pay some of the dancers to pose in his studio, did he work from memory, or, perhaps more intriguingly, did he draw them on the spot? Working in the

privacy of a theatre box, Degas might have experimented with these visual impressions of moving figures just as he had scribbled down his verbal impressions of the same subject; and given the size of the drawn figures and his distance from the stage, is it possible that he also used the opera glasses that he so insistently placed in the foreground of both painted versions of the scene?[4]

25. *Standing Dancer*
c1900
Charcoal on tracing paper
420 × 425 mm
The Syndics of the Fitzwilliam Museum, Cambridge

While many of Degas' ballet pictures were clearly intended to depict specific events in the dancer's routine and precise locations within the theatre, the same pictures remain amongst his most contrived and artifical productions. Degas was a frequent visitor to both the public and back-stage area of the Opéra building (where ballets were held) but all the evidence suggests that his pastels and paintings of the ballet were executed within the confines of his studio[1]. Apart from a few sketch-book studies of dancers and performances, even his working drawings were based on posed models or figures drawn from memory, and the finished paintings are often constructed from a bewildering variety of earlier imagery. Certain ballet positions, gestures and groups of dancers appear to have had a particular fascination for Degas, and these features crop up again and again in different pictures and at different phases in his career[2]. Sometimes a model would be freshly posed in a familiar position though Degas also made direct tracings or copies from his own earlier drawings. 'Stand-

ing Dancer' is one such drawing, executed in charcoal on tracing paper, which depicts a dancer who reappears repeatedly in a group of late ballet pictures.

The model in 'Standing Dancer' has both feet firmly and symmetrically on the ground, while her torso bends towards us and her hands and arms rearrange her tutu. Her head is angled a little to one side, while her less distinct arm appears to be tucked behind the small of her back. This precise pose occurs in a series of drawings, pastels and oil-paintings dated by George Shackleford to the turn of the century and there can be little doubt that the 'Standing Dancer' was part of that series[3]. More significantly in the present context, if the same pose is imagined from the rear rather than the front view, it coincides closely with figures in 'Two Dancers in their Dressing Room' (cat 21) and 'The Red Ballet Skirts' (cat 22). This reiteration of poses in Degas' work, which can also be found in his nudes and horse-race scenes, might cast doubt on any claims to realism that his pictures may have. The process certainly has a distancing or de-personalising effect, suggesting that his models were mannequins to be manipulated according to the criteria of picture-making. In this, Degas largely follows conventional practice, though the bland anonymity of his interchangeable dancers can

seem chilling beside his highly particularised portraiture.

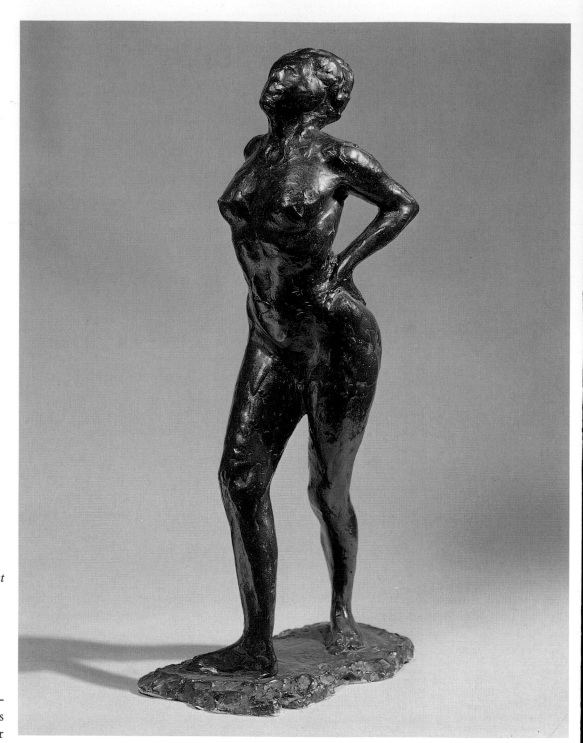

26. *Dancer at Rest, her Hands on her Hips, Right Leg Forward*
c1890
Bronze
457 × 152 × 229 mm
Trustees of the Tate Gallery

Degas' sculptures of the dance form an important though still rather mysterious aspect of his work. Their importance is evident in their great technical and visual originality, their precise integration with much of Degas' two-dimensional imagery, and in the dedication which the artist brought to their execution. The mystery of the dance sculptures is twofold. Firstly, unlike the majority of Degas' ballet pictures, the sculptures (with one exception) were never exhibited in the artist's life-time and seem to have been unknown to all but a few close friends. Secondly, and again in contrast to the majority of his pastels and paintings, the sculptures of the ballet show the dancers completely naked, in frank contradiction of the nature and the practice of the classical dance[1]. These issues, and other problematic questions concerning Degas' sculpture, have been dealt with in a number of recent publications, though the significance of the sculptures as images of women has rarely been discussed[2].

'Dancer at Rest', like the majority of Degas'

sculptures, depicts a pose which also occurs in a number of his works on paper and canvas. This substantial and muscular woman, her hands resting on her hips as if to support her tired body, reappears as a dancer in the wings and, with slight variations, as a naked bather relaxing in her bedroom[3]. As in so many of Degas' studies of dancers, emphasis is placed on the hard work involved in her profession and on the unglamorous nature of her physique. While the *prima ballerina* might be renowned for her sophistication, many of the other dancers came from humble backgrounds and had earned their places in the chorus through gruelling exercise and rehearsal. Degas unflinchingly records their stocky legs and assertive shoulders, their disciplined postures and their prominent musculature. The faces of the women remain generalised or ill-defined, like so many of the faces on his painted dancers, though the body is particularised and idiosyncratic. While Degas' intentions in making sculptures like 'Dancer at Rest' remain unclear, there is some evidence that these anonymous and asexual dancers may have been used in place of models in the composition of his pictures.

7. Muybridge, 'Woman Sitting Down in Chair and Pulling on Stocking', 1887. Photograph.

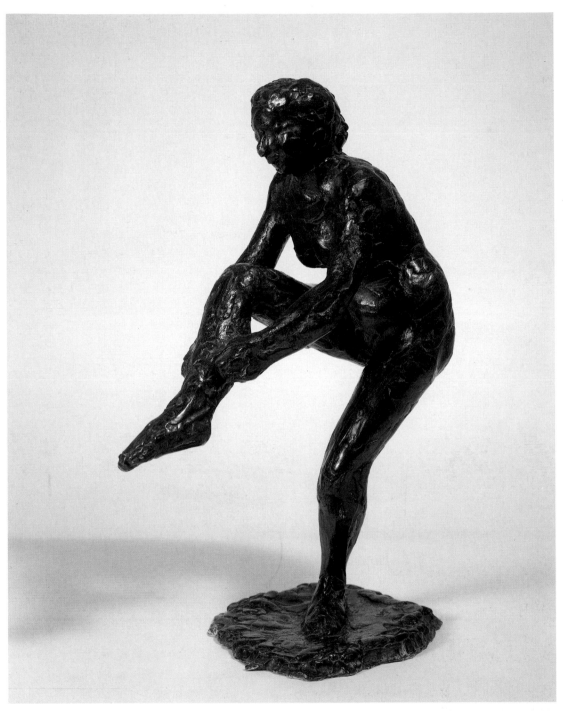

27. *Dancer Putting on her Stocking*
c1900
Bronze
470 × 222 × 267 mm
Trustees of the Tate Gallery

One of the great themes of Degas' art is that of movement, from the canter of a race-horse to the gestures of a singer, and from the dainty steps of a dancer to the awkward fumblings of a bather. Many of his sculptures of the dance show a figure caught in mid-movement, often at a critical point in a sequence of dynamic and unsustainable actions. Poses like that in 'Dancer Putting on her Stocking' or in the series of 'Arabesques' (cat 28–31) could not be held by a dancer or a professional model for more than a few minutes, and even the sculptures themselves can seem unstable on their modest bases. The sense that we are glimpsing a frozen moment, a fragmentary event amongst a series of events, is very pronounced, and is encouraged by many of the known circumstances of Degas' sculptural activity. In a much-quoted description of a visit to Degas' studio, Walter Sickert described how 'he showed me a little statuette of a dancer he had on the stocks, and – it was night – he held a candle up, and turned the statuette to show me the succession of shadows cast by its silhouettes on a white sheet'[1].

'Dancer Putting on her Stocking' is one of three sculptures of this subject made by the artist, all of them showing virtually the same pose. The 'Arabesques', on the other hand, belong to a larger group of works that represent variations on a single position; if these variants are arranged in the appropriate order, they are found to depict the individual phases of a continuous ballet movement. Although there is no documentary evidence to prove that this corresponds with Degas' intention, his interest in the depiction of sequential action is well established. A number of pastels and paintings show figures arranged in related and successive positions, while the artist's own photographs demonstrate a precocious involvement with proto-cinematic techniques[2]. More significantly, it is known that Degas was familiar with the high-speed photographs of Eadweard Muybridge and that he based certain drawings and even specific sculptures on them[3]. 'Dancer Putting on her Stock-ing' may have been suggested or encouraged by one of Muybridges's sequences and its improbable poise certainly seems more documentary than classical in origin (fig 7). The series of 'Arabesques' is even closer to Muybridge in spirit, though here Degas' documentation is frankly combined with an admiration for the dancers' discipline and elegance.

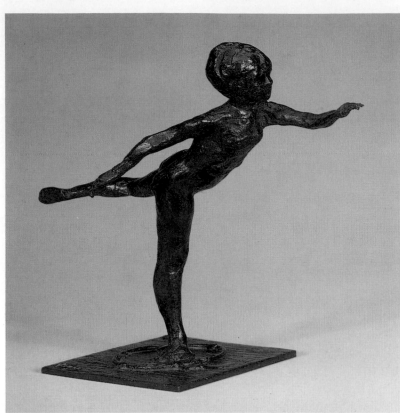

28. *Arabesque over the Right Leg, Left Arm in Front*
c1882–95
Bronze
206 × 255 × 103 mm
The Syndics of the Fitzwilliam Museum, Cambridge

29. *Grande Arabesque, Second Time*
1880
Bronze
480 × 310 × 620 mm
The Archdale Collection (on loan to Birmingham Museums and Art Gallery)

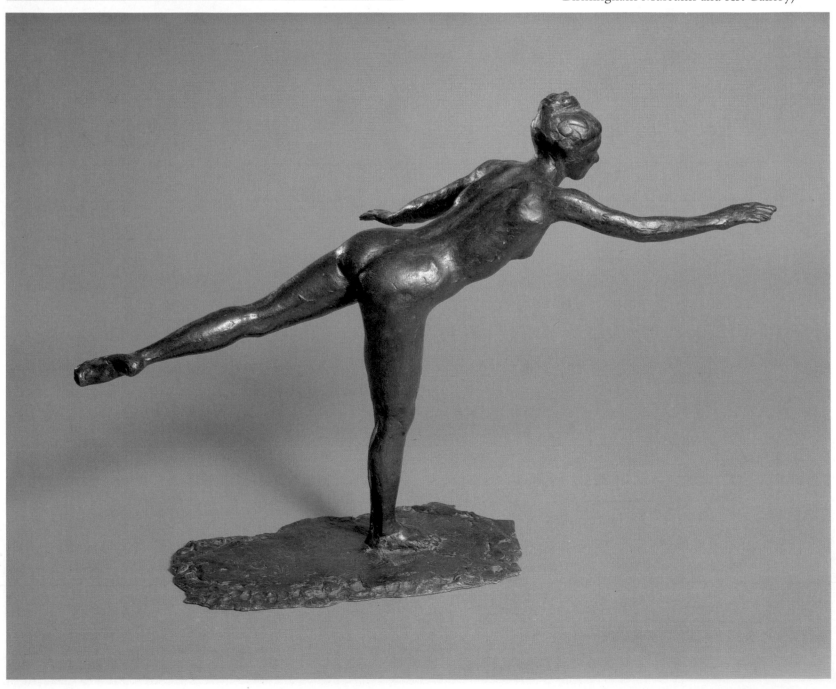

30. *Arabesque over the Right Leg, Left Arm in Line*
c1882
Bronze
305 × 450 × 95 mm
Leicestershire Museums and Art Galleries

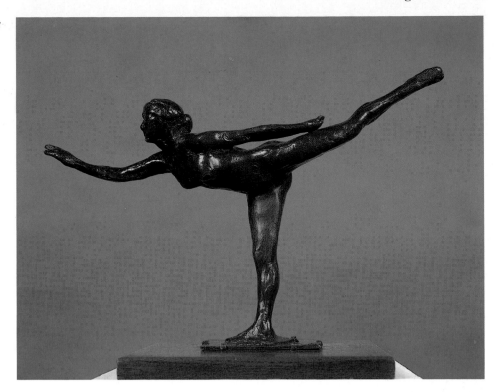

31. *Grande Arabesque*
1885–90
Bronze
400 × 508 × 343 mm
Trustees of the Tate Gallery

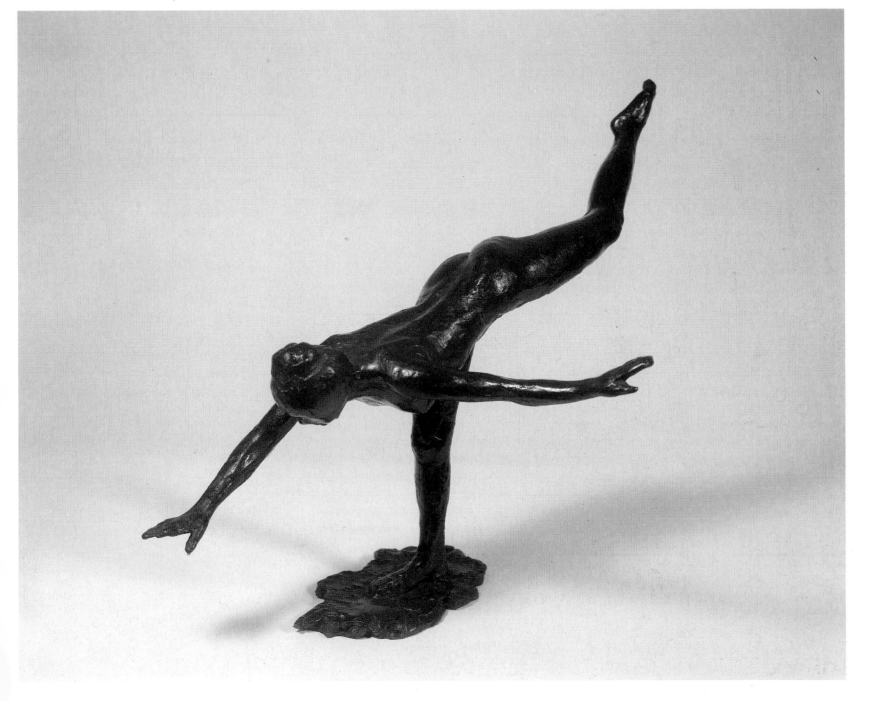

A number of attempts have been made to relate Degas' obsession with the female form to his own relationships with the opposite sex. Whatever the merits of such an approach, in Degas' case the documentary materials are so limited that its results are invariably unsatisfactory. It is known that his mother died when he was thirteen years of age, that he never married and that he was accused of misogyny during his own life-time[1]. On the other hand, Degas had several long-standing and mutually respectful friendships with women and went to some lengths to encourage female artists such as Mary Cassatt, Marie Braquemond and Suzanne Valadon. Many of Degas' images of women show his fascination with their occupations and skills, with their leisure activities and their rituals of fashion and public display. A substantial number of his pictures and sculptures, however, cross the threshold from this public world to the private domain of the woman's dressing-room and the bedroom. It has been argued that Degas, as a bachelor, had no legitimate business in such places and that all his nude and bather scenes must therefore be based on brothels[2]. While it may not be appropriate to speculate on such matters, such an assumption is surely misdirected. Though we know little about Degas' relationships with women, a great deal has been learnt about his approach to the making of works of art. Almost all Degas' pictures were made in the studio, away from the original subject, and painstakingly constructed from working drawings, memories and the poses of the model. His studies of rehearsal rooms and milliners shops, laundries and theatre boxes were largely the product of studio contrivance, and there is every reason to believe that his scenes of the *toilette* were made in the same way. As Degas himself said; 'a picture is first of all a product of the artist's imagination'[3].

There is an unusually extensive documentation of Degas' use of professional models. His early note-books include models' addresses and references to their distinguishing features, two of his models wrote down their reminiscences of the artist, and there is even a painting of Degas making an appointment for a posing session[4]. It is known that Degas' studio contained a selection of chairs, screens, draperies and bath-tubs, amongst which the model would be posed according to the demands of the work in hand[5]. By introducing a particular item of furniture or accentuating a studio prop, Degas could suggest a bathing scene or a boudoir, an amply upholstered dressing-room or a back-street brothel. Similarly, the artist was free to select a particular female physique that he considered suitable for the scene, choosing from the thousands of professional models then available in Paris. As the years went by, Degas increasingly chose the ample forms of models who were past their youth (a preference that he shared with his contemporaries Cézanne and Renoir), though it is interesting to note that such figures were often, and largely irrationally, associated by the critics with prostitution. While it is true that artists' models had a reputation for promiscuity, there are also accounts of their professional propriety and it appears that Degas was known for his strict studio etiquette[6].

Degas' depictions of the *toilette* were part of his analytical, imaginative and always self-conscious encounter with the female image. Just as he followed their public counterparts through the routines of a working or a leisurely day, so Degas catalogued the private woman's progression through her most intimate actions. First stepping into her bath or kneeling in her tub, then washing, sponging and drying her body, the woman moves on to the dressing of her hair and the final ministrations of the maid. Seen together, as Degas must often have seen them, these images suggest a frieze or an unfolding tapestry that encompasses both movement and duration. Like Monet's Series paintings or Degas' own monotypes of the landscape, the pictures and sculptures of bathing have a cumulative force that challenges the fixity of its individual elements.

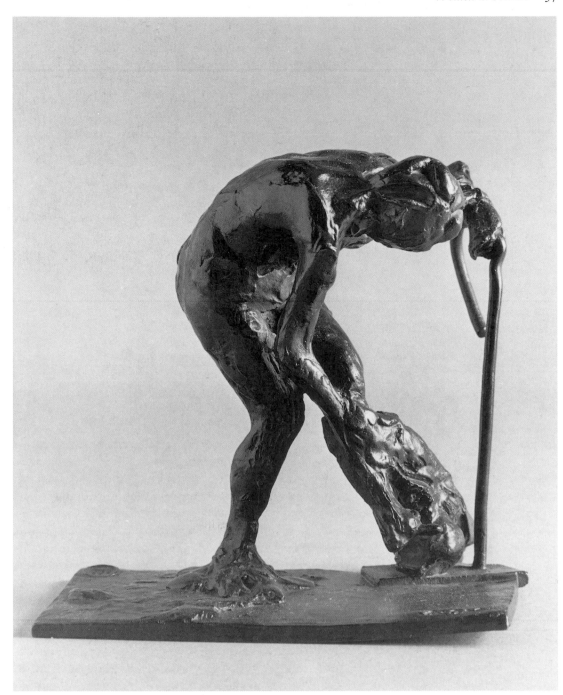

32. *Woman Washing her Left Leg*
1895
Bronze
145 × 120 × 120 mm
Walsall Leisure Services Department
Arts and Cultural Services Division
from the Garman-Ryan Collection

The sculptures made by Degas of women at their *toilette* are technically his most ambitious and original works in the medium. They include studies of women stepping into baths, seated on armchairs, lying on their backs in tubs and even forming a group with a second figure[1]. The original waxes modelled by the artist, from which the bronzes were cast, incorporate real pieces of fabric and other 'found objects' such as a small ceramic bowl. Many of the subjects of these sculptures relate very closely to the artist's works in pastel and oil-paint, suggesting a complex and reciprocal relationship of influence between his two-dimensional and three-dimensional imagery. However, any attempt to understand Degas' bather sculptures principally in terms of their technical or formal originality is surely misplaced. Of all Degas' sculptures of women, these are the most particularised and descriptive, showing events which were part of the woman's familiar and intimate routine.

The action depicted in 'Woman Washing her Left Leg' is best understood in relation to another sculpture with the same title that is both larger and more complete[2]. In this alternative version the artist included a tub beside the woman's raised foot, a chair to support her free hand and several pieces of modelled drapery to suggest discarded clothes or towels. Strictly speaking, the woman appears to be drying her leg rather than washing it, though the small scale and fragmentary state of the present sculpture tend to obscure her actions. Degas was notorious for the haphazard nature of his sculptural techniques, often using pieces of wood or wire to prop up his waxes as he modified or extended their poses. 'Woman Washing her Left Leg' is one of these partly resolved studies, suggesting a variant on the larger sculpture in which the woman leans forward with her left arm towards a still-undefined chair-back or vertical support. Small and incomplete though the figure is, the vivid modelling of the wax shows something of the ingenuity and dynamism of Degas' handling of the medium.

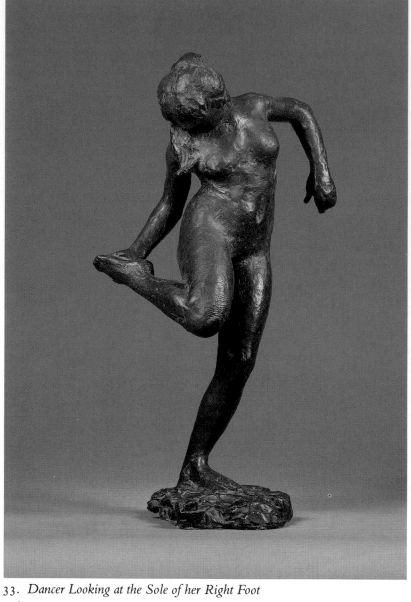

33. *Dancer Looking at the Sole of her Right Foot*
c1890
Bronze
457 × 250 × 155 mm
National Museum of Wales, Cardiff

The title that has become associated with this series of sculptures is a hindrance as much as a help in grasping their significance. With the inevitable exception of the 'Little Dancer Aged Fourteen', Degas did not title his own sculptures and we have only the evidence of the waxes themselves, and their related drawings and pastels, to indicate their original subjects. While Degas did sometimes blurr the distinction between dancers and nudes in his later work, there are no indications that this present series was intended to evoke the dance. Apart from their improbable nudity, these figures do not adopt a standard position from the dance repertoire and their poses are not associated with Degas' two-dimensional representations of the ballet[1]. Richard Brettell was surely closer to Degas' intentions when he noted the resemblance between this series and some late bathing scenes[2]. The figure clambering into or out of her bath, or drying one of her feet, offers the most plausible explanation of the pose and suggests that this group of sculptures belongs amongst Degas' late studies of the *toilette*.

While the pose remains somewhat enigmatic, these figures are perhaps the most admired of all Degas' sculptures. The artist himself was evidently fascinated by the subject. Four closely-related variants of the figure exist, and a number of other associated studies, and it appears that Degas returned to the pose several times over a period of ten or fifteen years. Unusually in the context of this artist, one of the few surviving accounts of his studio practice gives specific information about the evolution of these works. Degas' model Pauline, in her rather over-written but essentially believable memoirs of the artist, describes how she had to 'balance on her left leg, while struggling to hold her raised right foot behind her with her right hand'[3]. She goes on to describe the discomfort of the position and her difficulties in maintaining it for long periods of time, and inevitably her account raises the question of Degas' intentions in choosing such an unstable and unconventional pose. In each of the sculptures, the woman's weight is supported on a single leg and her centre of gravity is high up in her torso. While her limbs and head create an equilibrium in space, the implicit instability of her position suggests movement and an almost gravity-defying upward momentum. While no precise equivalents to the pose exist in Muybridges's sequential photographs, the same sense of momentarily frozen dynamism once again informs this remarkable sequence of sculptures.

As in so many of Degas' late representations of the nude, the woman's sexuality does not become the central issue in these works. Though her body adopts an open and unselfconscious pose, her breasts and pubic region are not emphasised and are represented in a very generalised fashion. At the same time, attempts to relate these figures to a Classical tradition or to the purely formal development of sculpture are surely of limited significance. Degas was an erudite artist whose knowledge of past art frequently informs his own work, but this series of sculptures is insistently, abras-

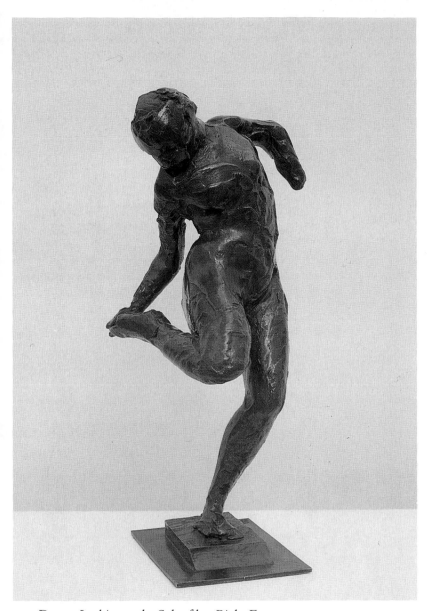

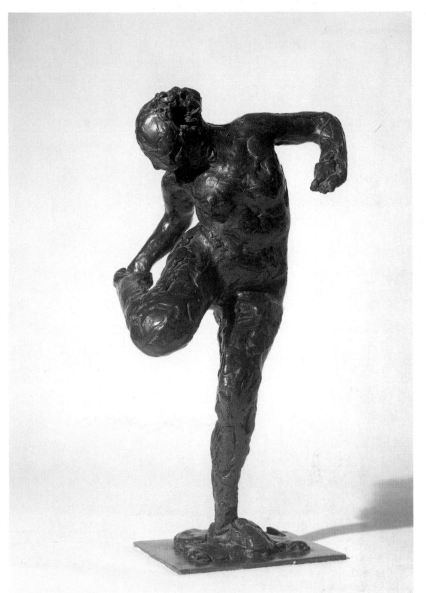

34. *Dancer Looking at the Sole of her Right Foot*
c1900
Bronze
455 × 260 × 210 mm
Private Collection

35. *Dancer Looking at the Sole of her Right Foot*
1910–11
Bronze
476 × 267 × 216 mm
Trustees of the Tate Gallery

ively modern. The emphasis on the woman's dynamic articulation is the antithesis of her traditionally passive role; the physical effort involved in the pose is clearly spelt out, as is the muscular character of her limbs and torso; the physical, almost animal quality of a naked body is unflinchingly celebrated, reminding us perhaps of the artist's own claim on one occasion that 'these women of mine are honest, simple folk, unconcerned by any other interests than those involved in their physical condition'[4].

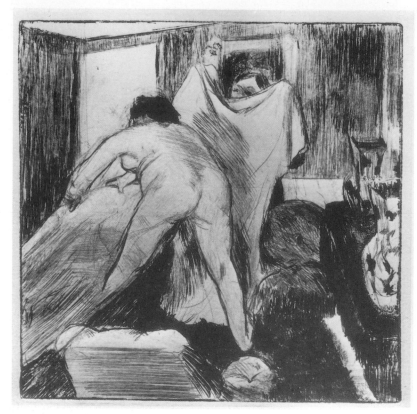

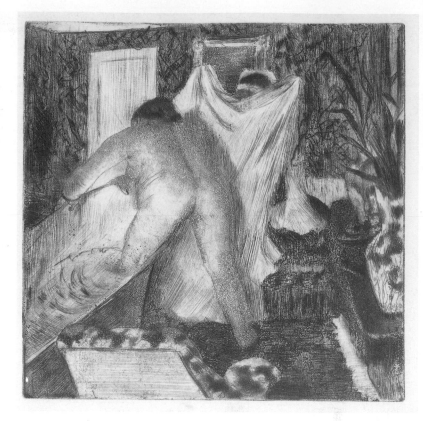

36. *Leaving the Bath, 3rd state*
1879–80
Drypoint and aquatint
127 × 127 mm
Josefowitz Collection

37. *Leaving the Bath, 18th state*
1879–80
Drypoint, aquatint and electric crayon
126 × 128 mm
Josefowitz Collection

The subject of the woman bathing or washing herself became one of the major obsessions of Degas' maturity. He treated the theme in all the media at his disposal, including sculpture, print-making and photography, and on every scale from the minute to the monumental. As a subject it is rich in associations and resonant with historical precedent. The bathing scene has accomodated nymphs and goddesses, biblical heroines and ladies of the harem, and has been used for moral instruction as well as erotic display. Some of Degas' favourite paintings were scenes of the bath, notably Rembrandt's 'Bathsheba' and Ingres' 'Valpinçon Bather'. On more than one occasion Degas argued that his own work was part of this tradition, but his recorded observations, such as the much-quoted 'Two centuries ago I would have been painting 'Susannah Bathing', now I just paint 'Woman in a Tub'' point equally to the disjuncture of this tradition[1]. Images such as 'Leaving the Bath' are aggressive in their modernity, insistent in their description of furnishings, accessories and contemporary behaviour. It is urban rather than rural, awkward rather than graceful, inconsequential rather than morally significant. If it were possible to imagine a picture subverting, rather than upholding, the Bather tradition, it would surely look something like this.

Degas produced 'Leaving the Bath' at the height of his enthusiasm for 'modern life' subject-matter and at a time when he was much involved in experimental print-making techniques[2]. He reworked the plate many times (twenty-two states have been identified), adding new areas of decoration and tone to walls, floor and figures, introducing flowers into the ornamental vases and finally wearing the image out almost completely. Throughout this process, the essential elements of the composition remained unaltered. The unusually abrupt perspective, emphasised through the angled mantelpiece and bath-tub, was established at the beginning, suggesting a viewpoint that is both intimate and over-bearing. The extraordinary figure of the bather, surely one of the most unglamorous and unforgettable nudes in Degas' or any other artist's work, was also part of the original conception. Her truncated rear view and splayed legs clearly fascinated the artist, who developed a number of other variations on her pose at about this time. Using monotype and pastel, Degas rotated around the fixed position of the model, showing her from the front and from the left and right sides, in a way that recalls the preparatory drawings for his sculpture of the 'Little Dancer Aged Fourteen'[3].

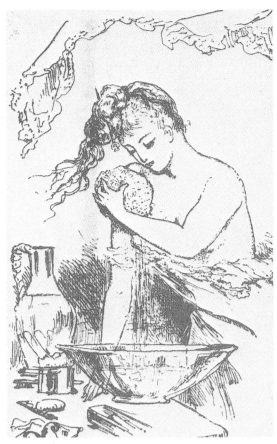

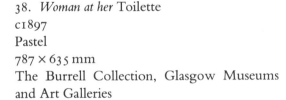
8. De Montaut, 'Studies of the *Toilette*' (detail), La Vie Parisienne, 1881.

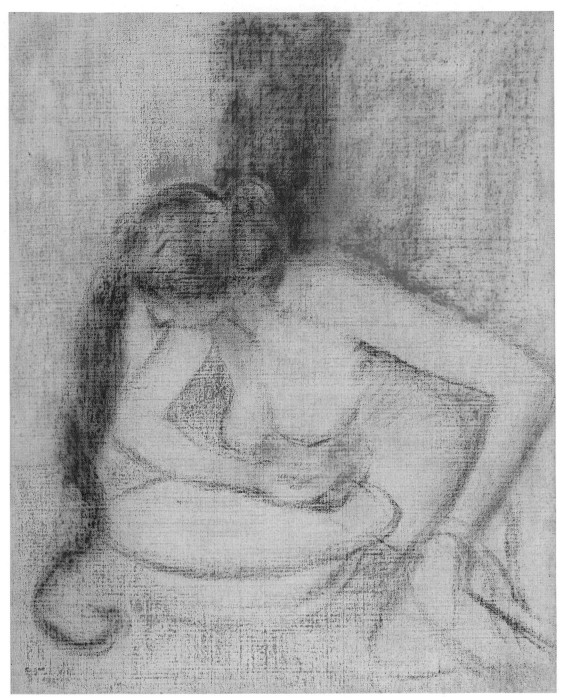

38. *Woman at her* Toilette
c1897
Pastel
787 × 635 mm
The Burrell Collection, Glasgow Museums and Art Galleries

This little-known pastel belongs to a group of closely-related pictures produced by Degas towards the end of his career[1]. Technically, it is highly unusual, combining charcoal lines and broad areas of pastel on an exceptionally coarse canvas support, and it should almost certainly be regarded as a masterful, but unfinished, compositional experiment. The woman depicted is involved in the most commonplace process of washing known to Degas and his contemporaries. She has undressed in the privacy of a bedroom (not a bathroom) and stands in front of a table or wash-stand, sponging herself with water from a metal or ceramic bowl. Innocent though the scene may appear, its relationship to the artist's other work and to the social conventions of the day raises a number of questions. The process of washing involves nudity, intimacy and, in many of the representations of the subject in past art, sexuality. Is this woman alone and self-absorbed, or does the picture imply a spectator? If another person is present, is that person a husband, a lover or an intruder? Is the woman engaged in a plaus-

ible activity, or is her body displayed for our benefit? Is this an anonymous Parisian housewife, a posed artist's model or a prostitute?

The generalised and unfinished state of 'Woman at her *Toilette*' provides few answers to these questions, but the other pastels from the same group are both more detailed and more explicit. In a procedure which is typical of the artist's later years, Degas repeated the same essential pose in at least nine pastel variants, introducing water-jugs, towels, drapery and even a picture on the background wall. In one version a maid is visible, but otherwise there are no references to spectators (either male or female) or to the paraphernalia of a brothel. The erotic connotations of the scene are not, however, insignificant, and our implied presence in the woman's dressing room and the proximity of our view-point are both suggestive. It is one of the curious paradoxes of Degas' representations of the nude that he typically conceals or suppresses the

female breast, but in this unusual series the breasts are supported and emphasised by the washing action. While avoiding many of the conventions of the soft-pornographer (such as the establishment of eye contact), Degas does use the licence of art to depict the nude more frankly than a comparable representation in the popular press of the day (fig 8).

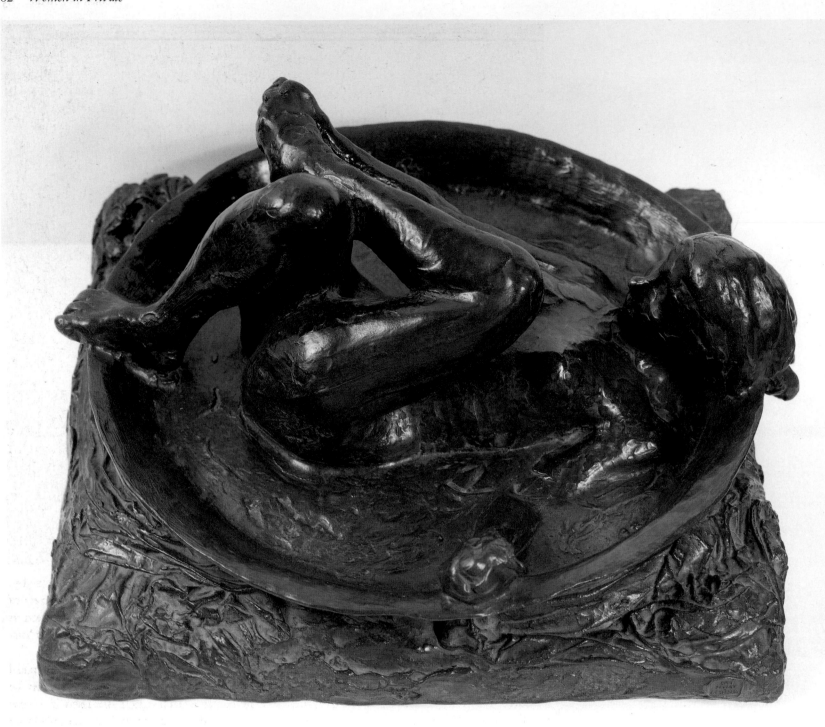

39. *The Tub*
c 1889
Bronze
222 × 457 × 420 mm
National Galleries of Scotland, Edinburgh

It has recently been suggested that 'The Tub' occupies a position of importance (in Degas' sculpture) parallel to that of 'The Little Dancer Aged Fourteen'[1]. The original sculpture incorporated a wax figure holding a real sponge, a lead tub with 'water' made from plaster, and real fabric around the base. The familiarity of these materials and the casual nature of the woman's pose were both made more remarkable by the highly original view-point demanded by the sculpture; while the figure and her position are entirely coherent from the side, this is a rare example of a sculpture that achieves maximum legibility when viewed directly from above. In this sense, 'The Tub' aligns itself with a number of pastels of figures seen from unusual or challenging points of view, and with Degas' known interest in the subversion of visual conventions[2]. It also joins 'The Little Dancer' and the remaining Bather groups (see cat 32) on the boundaries between realism and artifice, on the one hand celebrating commonplace objects and experiences, while on the other asserting the artificiality of art.

A number of recent studies of Degas have examined the significance of bathing and washing in his art[3]. It has been pointed out that bathrooms and bath-tubs were features of only the most prosperous houses and that excessive washing was even believed to be injurious to the health. A portable bath, such as that shown in 'Leaving the Bath' (cat 36), had to be laboriously filled from jugs or buckets and presupposed the availability of a maid. Bathing and washing, on the other hand, were associated with prostitution, both as erotic display and as a hygienic practice required by law; the presence of a bath-tub in a painting, it is argued, would tend to identify that scene as a brothel and the woman in the bath as a prostitute. While certain of Degas' images of bathing support this interpretation, notably through the inclusion of male customers or specific references to brothel furnishings, they remain in a small minority. The presence of a shallow metal bath-tub such as that in 'The Tub' suggests neither affluence nor exhibitionism, since such items were commonly found in a variety of homes[4]. Any tendency to generalise about Degas' bathers will inevitably be misleading, since the artist himself approached different types of nudes in different ways and characteristically delighted in the ambiguous and the indeterminate.

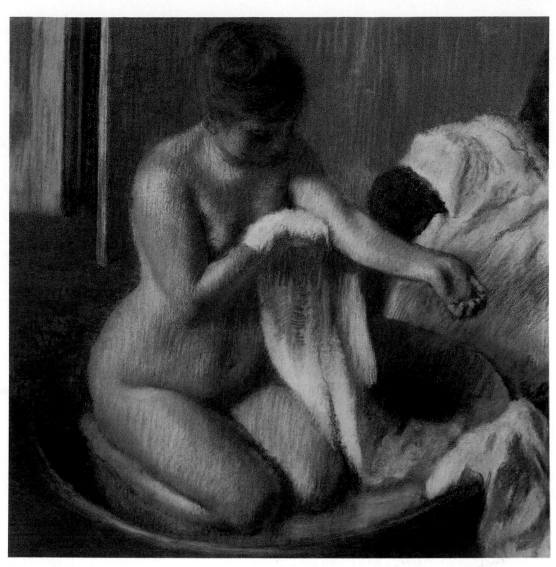

40. *Woman in the Tub*
c1886
Pastel on paper
698 × 698 mm
Trustees of the Tate Gallery

This pastel in one of the most delicately executed and finely resolved of all Degas' studies of the nude. It belongs to a celebrated series of pastels of women at their *toilette* produced in the mid-1880s, a group of which was included in the 1886 Impressionist Exhibition. Opinion is divided as to whether 'Woman in a Tub' was amongst that group, but in almost every respect it conforms to them in subject-matter, scale and technique[1]. The 1886 exhibition was Degas' most dramatic and public identification with the subject of the female nude, and the response by the critics was correspondingly extensive. More than twenty references to Degas' suite of nudes have been discovered, varying from the reviews of writers such as Geffroy and Huysmans to the facetious asides of anonymous journalists. Reactions varied widely; most of the critics were impressed by the visual power of Degas' images and many commented on their accuracy, skilfulness and originality[2]. A common theme was the courageous realism of the nudes and the way in which Degas showed plausible contemporary women rather than idealised goddesses or milk-white nymphs. More controversially, several of the reviewers noted the ugliness of the models and explicitly identified them as prostitutes, claiming that Degas showed a 'disdain for women and a horror of love'[3].

The related questions of Degas' supposed misogyny and the nature of the women he depicted have been much discussed in recent years[4]. While it has rightly been accepted that some of his pictures refer explicitly to brothels, there has been an over-readiness to apply this interpretation to all the artist's nudes. Many of Degas' contemporaries were much more equivocal. Pictures such as 'Woman in a Tub' were admired for their 'harmony' and their 'loveliness', some of the models were identified as artisan's wives or even 'bourgeoises', and one reviewer went so far as to call them 'chaste'[5]. As his monotypes show, Degas was eminently capable of indicating a brothel interior or the routines of prostitution if he so wished, and the distinctive feature of most of the pastel nudes is their *lack* of such indicators. The confusion amongst Degas' contemporaries surely followed his calculated and skilful neutralisation of their normal responses to such pictures; were these nudes admirable or base? how could they tell? were they ugly or beautiful, rich or poor? where was the evidence? could they even have been their own lovers and wives?[6]

41. *The Bath, Woman Seen from Behind*
c1895
Oil on canvas
650 × 810 mm
Private Collection

In the 1890s, Degas painted a remarkable series of canvases of the female nude which depict moments of sudden exertion or violent physical strain. These pictures are not widely known and have never been studied as a group, but they seem to represent a distinct departure in Degas' late career, or possibly a return to one of the tormented themes of his youth[1]. Not only do the canvases show striding, twisting and spread-eagled figures, but the way in which they are depicted intensifies the drama of their actions. In this series Degas used oil-paint with a freedom unprecedented in his earlier career, gesturing almost wildly in the underpainted layer and building up dense textures with brushes and finger-tips. Other pictures from the series incorporate brilliant swathes of orange-brown or blue pigment and flourishing outlines in black and umber, as well as the extraordinary stippling technique that features so conspicuously in 'The Bath, Woman seen from Behind'. This canvas has one of the richest surfaces and the most original colour-harmonies of any of the group, and an examination of its paint-layer suggest that the majority of the pigment was applied not with a brush but with the artist's hands[2].

The pose of the model in 'The Bath' is both forceful and enigmatic. She appears to have recently left the bath-tub and seated herself in a low, towel-covered chair, while a maid dries or brushes her hair. In two of the preliminary drawings for this picture Degas placed a towel in the woman's left hand, but his exclusion of the towel in the final work leaves her gesture unexplained. Is she massaging herself or being massaged, like a rather similar figure in a sculptured group of the same date?[3] Is she bracing herself, or even expressing discomfort and pain, as her angled torso and limbs might suggest? It has been proposed that a number of these late nudes represent scenes of violence or physical assault, though the presence of the maid in the foreground of 'The Bath' (apparently included at a late stage by the artist) must exclude such an interpretation here. While many of the features of this canvas show the calculated ambiguity so characteristic of the artist's later work, the image also seems to celebrate the intense physicality of bathing and the state of nudity. In a memorable sequence in Zola's novel *Nana*, the heroine luxuriates in her own nakedness, contorting and caressing her body in an almost violent manner which comes close to the subject of 'The Bath'[4].

Like the great majority of nudes in Degas' paintings and pastels, the figure in 'The Bath' is

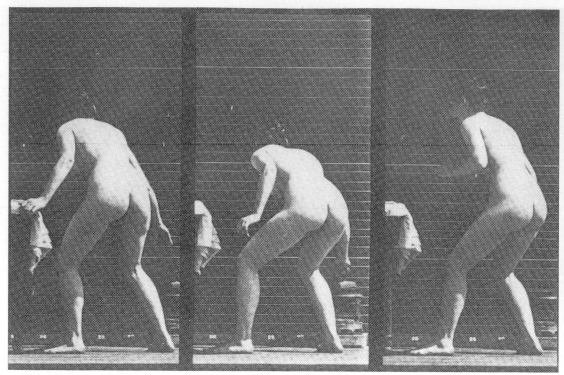

9. Muybridge, 'Woman Standing and Ironing', 1887. Photograph.

directed away from the viewer, her face averted and her naked back the most prominent feature of the composition. The back was the subject of one of the formative pictures of Degas' career, Ingres' 'Valpinçon Bather', and it pervades his own work from representations of the dance (cat 21) and the cabaret (cat 17) to occasional portraits, such as 'Mary Cassatt at the Louvre' (cat 9). Degas' obsession with the back takes on a particular significance in the context of the nude, defining both his own vantage point and his implicit relationship to the woman depicted. In 'The Bath' the position of the model excludes the possibility of eye-contact, suggesting that the observer is an unacknowledged or even undetected presence in the room. The much-quoted claim, attributed to Degas by George Moore, that these scenes represent the nude 'as if you looked through a key-hole', is taken from a context in which the artist specifically denies a voyeuristic or sexually charged significance for his nudes[5]. However, the vantage point in 'The Bath', which is both physically adjacent and psychologically distanced, is essentially foreign to normal experience. Certain disjunctures within the picture, such as that between the scale of the maid and that of the nude, and the ambivalent relationship between the chair and floor, create a heightened sense of insecurity which may or may not have been intended by the artist. Certain other sculptures and pastels from this period, in which the model is shown covering herself in a startled pose or possibly shielding herself from an intruder, suggest a specific interest on Degas' part in scenes of discomfort and threat[6].

One of the preparatory drawings for this painting is signed in two places, indicating that

it can be viewed both as a horizontal and a vertical image[7]. It has also been suggested that the pose of the nude began as a standing figure and was then turned through ninety degrees to produce an unusual bather pose[8]. Degas' interest in highly animated poses seems to have been greatly stimulated by his study of Eadweard Muybridge's photographs (his *Animal Locomotion* was published in France in 1887) and a further source for this figure may have been one of his sequences of a female nude in motion (fig 9).

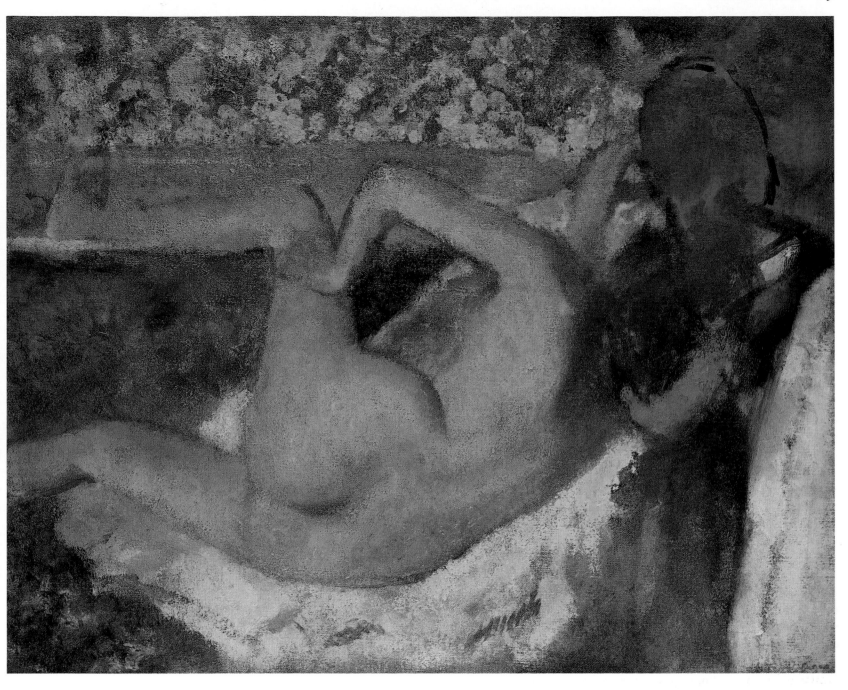

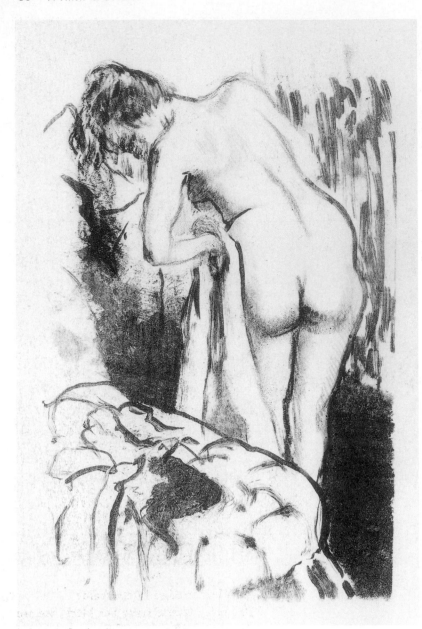

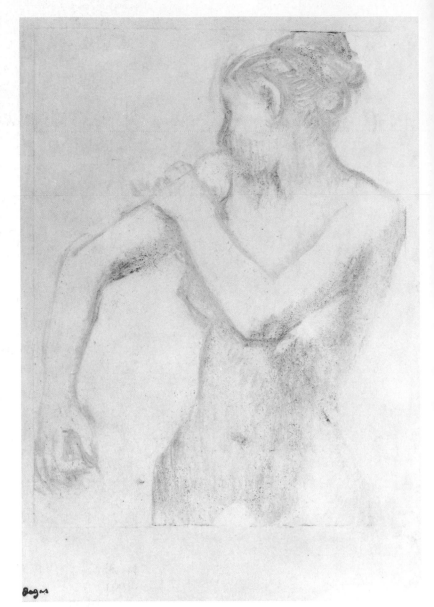

42. *Nude Woman Standing Drying Herself*
c1891–2
Lithograph on paper
355 × 248 mm
Trustees of the British Museum

43. *Standing Woman, Washing Herself*
c1885
Monotype
359 × 267 mm
Private Collection

The subject of the woman drying herself accounts for more of Degas' representations of the nude than any other single theme. In literally hundreds of drawings, pastels, prints, oil-paintings and sculptures, Degas depicted the naked model after she has bathed or washed, wiping her feet or legs, drying her back and arms, or massaging her neck, shoulders and spine. The women are shown standing and supine, seated on chairs and baths, and sometimes attended by a maid. The awesome variety of these variations on a single theme is evidence of both Degas' technical virtuosity and his visual inventiveness, but it also points to the obsessional nature of the artist's relationship with his subject-matter. The bather theme is rich in allusion and historical precedent, offering a range of associations from Classicism and the Old Masters on the one hand to modern sexuality on the other. Degas was an artist who delighted in such complexity of visual language and it has been argued that his nude subjects make specific reference to Venus and Susannah, and to the paintings of Rembrandt, Ingres, Delacroix and others[1].

'Nude Woman Standing Drying Herself' belongs to the last, and arguably the finest, series of prints made by Degas of the female nude. Executed in a complex and original combination of lithographic and monotype techniques, this print and its associated images were developed by Degas into a subtly inflected sub-series within the broader theme. 'Standing Woman, Washing Herself' is a pure monotype, unusual in both its half-length figure and its delicate, unspecific pose. In both images the woman adopts a composed and not ungraceful attitude, at the opposite extreme to the 'simian positions' and 'froglike aspects' that the critics found in the same artist's nudes in 1886[2]. Whether drying herself or washing, each woman is engaged in a purposeful and reflective action that is as close to the poise of a ballet-dancer as to the contortions of a monotype prostitute. As if to stress the analogy, Degas has placed the model in 'Standing Woman, Washing Herself' in one of his favourite dancer poses, one hand crossing to the opposite shoulder to adjust a ballet-dress or, in this case, to wash or dry her arm.

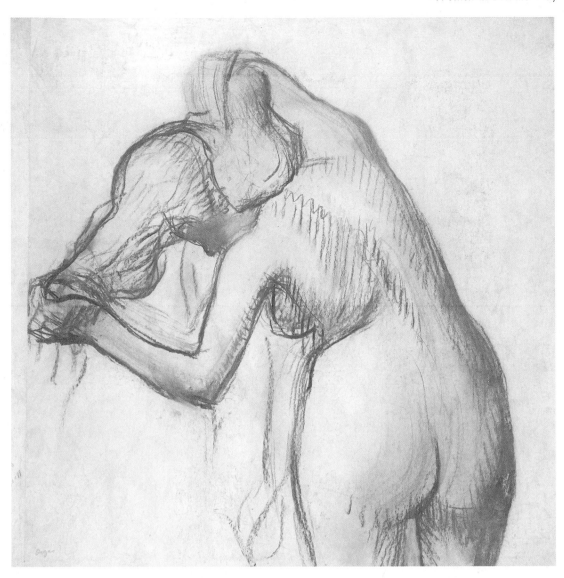

44. *Female Nude Drying her Neck*
c1903
Charcoal on tracing paper
793 × 762 mm
The Provost and Fellows of King's College,
Cambridge (Keynes Collection) on loan to the
Fitzwilliam Museum

This large charcoal drawing on tracing paper is characteristic of one of the technical procedures of Degas' later career. Working directly on to such paper, or transcribing an image from another pastel or painting, Degas would use the tracing process to develop a series of new variations on existing studies of dancers or nudes. By varying the colour range, the background details or the precise configuration of the model's pose, Degas produced an encyclopaedic progression of inter-related and inter-dependant images of the female body. Certain poses and preoccupations recur; in this case, the flattened back which bends sideways into the plane of the picture, the raised and angled arm which dries the neck, and the counterbalancing downward thrust of the woman's hair are all familiar from other works by the artist. Most characteristic of all is the artist's chosen view-point, emphatically positioned behind the naked woman and yet close enough to her for parts of her figure to be 'cropped' by the edges of the frame.

In 'Female Nude Drying her Neck' we are shown a partial silhouette of the woman's face and a glimpse of her left breast, but it is her torso, limbs and hair which dominate the composition. It has often noted that Degas tended to conceal or suppress the faces of his nudes and it is difficult to avoid the conclusion that he was primarily interested in the expressive possibilities of their bodies[1]. The other consequence of Degas' preferred vantage-point has not, however, been so fully considered. By repeatedly depicting his models from the back, the artist not only drew attention away from their personalities but also from their sexuality. In comparison to the frontal nudes of the brothel monotypes or the clinically explicit images of contemporary pornography, the majority of Degas' bathing women are discreet in the extreme. While such a fixation on a particular feature of the female body by no means excludes a sexual interest, it can be argued that (short of not depicting the nude at all) Degas has distanced himself as far from the erotic and exploitative conventions of the subject as any artist of his generation could be expected to go[2].

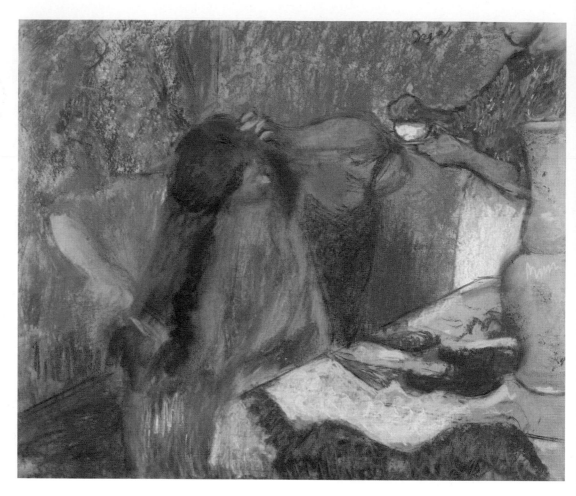

45. *Woman at her* Toilette
c1894–1900
Pastel on paper
956 × 1099 mm
Trustees of the Tate Gallery

Many of the scenes of the *toilette* depicted by Degas seem to have been chosen for their combination of dynamic movement with contained, balanced body positions. Degas' models rarely sit or pose impassively, tending instead to engage in some plausible activity that animates their figures and energises the picture space. In 'Woman at her *Toilette*' the pronounced diagonal that runs through the seated woman's shoulders and into the arm of the maid establishes a powerful, upward-moving axis to the composition. This movement is echoed in the table-top, but is dramatically balanced by the downward thrust of the woman's hair and the combing action of her right arm. Other rhythms within the picture amplify and enrich this essential structure, while certain elements, such as the ceramic jar and the front edge of the table, seem designed to contain the competing energies within the frame. The result is an emphatically physical image, contrasting the soft forms of the figure who vigorously combs her hair with the clearer outlines of the immobile maid, and stressing the contact between fingers and hair,

or hands and cup. The extraordinary richness of the pastel surface seems to accentuate this physicality, energising walls, fabric and furnishings in a virtuoso display of textures and hatchings[1].

The subject of the combing of the hair has as varied an iconography and a contemporary significance as Degas' other themes of the *toilette*. Traditionally associated with Vanity, the action of dressing the hair also has a long association with eroticism. In Edmond de Goncourt's *La Fille Elisa*, a novel that Degas is known to have read in the 1870s, several pages are devoted to a graphic account of the heroine's relationship with another prostitute, which largely consists of Elisa brushing the other woman's hair in highly suggestive circumstances[2]. While Degas was clearly aware of such connotations, he chose not to draw attention to them in his many pastels, paintings and sculptures of the subject. In a number of variations a second figure is present, but she is invariably a maid or attendant whose inferior status is signalled through her static pose, her drab costume and her partial effacement by the edges of the composition. While the subject of these images in never insignificant, Degas' rejection of the conventions of pedantic documentation and boudoir kitsch is evident in comparisons with more orthodox contemporary versions of the same subject (fig 10).

10. Fildes, 'An Al Fresco *Toilette*', 1889. Lady Lever Art Gallery.

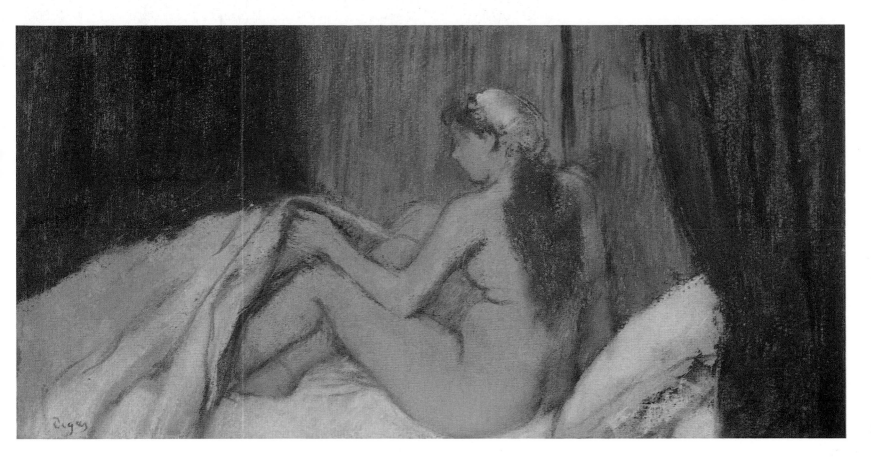

46. *Woman Getting into Bed*
c1880—5
Pastel over monotype
229 × 445 mm
Trustees of the Tate Gallery

Degas' systematic depiction of the phases of the female *toilette* appears to border on the comprehensive, but there are a number of events which are largely conspicuous by their absence. Most significant amongst these are the actions that begin the ultimate destination of the day's activities, whether solitary or otherwise, the bed. All these subjects form part of the standard repertoire of eroticism and pornography, and Degas' habitual exclusion of them from his art has important implications in the discussion on his imagery. There are exceptions, of which 'Woman Getting into Bed' is one, but they fall into two small and clearly defined groups. In the case of 'Woman Getting into Bed', it is a work based on a monotype and as such belongs to the self-contained and often exceptional world of those extraordinary prints. Conversely, one or two of the most distinctive and ambitious nude studies from Degas' career include references to a bed, but their significance is not always clear[1].

A close examination of the surface of 'Woman Getting into Bed' reveals a silvery-grey monochrome underlayer in several areas of the image. This is particularly evident in the region of the foreground curtain and pillow, but may also be glimpsed through the pastel layer of the woman's body. Like a considerable number of Degas' smaller pastels, this picture began life as a monotype, printed directly on to the paper from a drawing made in ink by the artist[2]. Following the composition and the tonal structure established by the monotype, Degas then worked on the image with his pastels, often submerging the original print under several layers of colour. 'Woman Getting into Bed' occupies a somewhat indeterminate position amongst these monotype and pastel works. Many of Degas' monotypes of nudes are explicitly related to brothel scenes, but these he almost invariably left uncoloured[3]. The monotypes which are most heavily developed in pastel tend to be Degas' more 'public' subjects, such as the ballet, though some examples of nudes with heavy pastel re-working are known[4]. In its technique and its subject-matter 'Woman Getting into Bed' is a curious hybrid, the suggestive nudity of the model more than neutralised by her quotidian nightcap.

CATALOGUE NOTES

Titles in italics are abbreviated references to the books and articles listed in *Works Frequently Cited in the Text* (page 71).
Numbers preceded by 'L' refer to pictures listed in *Lemoisne*.

WOMEN OF LEISURE

1. *Lemoisne* vol 1, opposite p 8.
2. *Broude 1977*, p 97.
3. The development of Degas' portraits of women is discussed in *Boggs 1962*.

CAT 1
1. In *Brame and Reff*, p 28, this painting is called 'Marguèrite De Gas en Pensionnaire'.
2. *Reed and Shapiro* no 3.
3. Jean Fevre, *Mon Oncle Degas*, Geneva, 1949.

CAT 2
1. L 129 and L 328
2. L 275, 278, 305, 306, 314–16, 323, 335, 357 etc.
3. See Jean Sutherland Boggs, *Degas and Maternity*, to be published in the papers of the Paris *Colloque Degas*, 1988.

CAT 3
1. Degas' experiments with monochrome underpaintings are discussed in Theodore Reff, 'The Artist as Technician', in *Degas, the Artist's Mind*, New York, 1976 and Richard Kendall 'Degas' Colour', in *Kendall 1985*.
2. *Boggs 1988* p 148, where the possible resemblance of this portrait to Degas' model Emma Dobigny is also mentioned.
3. See John Rewald et al *Edgar Degas, His Family and Friends in New Orleans*, New Orleans, 1965.
4. Notebook 22, p 43; 'Portrait of Mme Millaudon' in HR Hoetink, *Franse Tekeningen Uit de 19e Eeuw*, Rotterdam, 1968, no 90, p 77. See also *Boggs 1962*, p 124. The marks on the canvas beside the signature, which resemble a partially effaced inscription, have resisted attempts at decipherment.

CAT 4
1. Winterhalter's 'Pauline Sandor, Princesse Metternich' is cat 63 in Richard Ormond *Franz Xavier Winterhalter*, London, 1988. Boudin's painting shows the Princess with her retinue at Trouville.
2. The use of a photograph was noted by Suzanne Eisendieck and published by John Rewald, *L'Amour de l'Art*, March 1937.
3. *Lipton 1986*, p 44.
4. *Davis*, p 47.

CAT 5
1. *Davis*, p 53.
2. L 169 and L 637.
3. See Jean Sutherland Boggs, 'Edgar Degas and Naples', *Burlington Magazine*, June 1963.

CAT 7
1. Manzi is listed as the first owner of the picture; see L 920. There are some similarities between this composition and two apparently earlier sheets of drawings (L 260 and L 261), as well as some studies in Notebook 22, pp 109–117.

CAT 8
1. *Reed and Shapiro*, p 119.
2. The vexed question of the identity of the model is discussed by Michael Pantazzi in *Boggs 1988* pp 318–320.
3. It is suggested in *Pickvance 1979*, p 80, that earlier states of the print may show signs of a seated figure similar to that in 'Mary Cassatt at the Louvre' (cat 9).

CAT 9
1. See Theodore Reff, *Degas, the Artist's Mind*, New York, 1976, pp 134–136 and *Reed and Shapiro*, pp 168–183.
2. *Boggs 1988*, p 321.
3. *Moffett*, p 44.
4. Richard Thomson 'Notes on Degas' Sense of Humour' in *Kendall 1985*, p 14.

CAT 10
1. See Douglas Druick and Peter Zegers, 'Scientific Realism 1873–1881', in *Boggs 1988*.
2. *Moffett*, pp 44–45.
3. *ibid*.
4. *Valéry*, p 56.

CAT 11
1. See *Kendall 1988*, p 183.
2. A discussion of the female gaze in the work of artists closely related to Degas can be found in 'Modernism and the Spaces of Femininity' in *Pollock*, pp 50–90.
3. L 897 and 898.
4. *Boggs 1988*, pp 456–7.
5. *ibid*.

CAT 12
1. Lemoisne gives the title 'La Loge (femmes dans une loge)', L 873. The inappropriateness of the present title is also noted in *Pickvance 1979*.
2. L 476, 577, 737, 828, 829. Several of these variants are discussed in *Herbert*, pp 102–4.
3. If these are portraits and not 'dancers' they would presumably be based on recognisable individuals. The resemblance between the left-hand figure and Rose Caron (See *Boggs 1988*, pp 532–4 and L 862) is striking.

WORKING WOMEN

1. *Michel*, p 625; translation from *Kendall 1988*, p 316.
2. Daniel Halévy, *My Friend Degas*, London, 1966, p 53.
3. *Michel*, p 471.
4. *Michel* p 469.
5. *Broude 1988*.

CAT 13
1. See *Boggs 1988*, nos 122, 256, 257 etc.
2. Theodore Reff, *Degas, the Artist's Mind*, New York, 1976, pp 166–8 and *Lipton 1986*, chapter 3.
3. Another pastel version is 'La Repasseuse' in the Cabinet des Dessins, Musée du Louvre; a smaller version, in oil, is 'The Laundress' in the Norton Simon collection.

CAT 14
1. *Lipton 1986*, chapter 3.
2. The connection with 'L'Assommoir' is made in *Brettell*, p 122.
3. *Janis* no 259.
4. *Reed and Shapiro*, pp 149–53.

CAT 15
1. *Boggs 1988*, p 531.
2. *Moffett*, p 175.
3. *Lipton 1986*, chapter 3.
4. The drawing of his friend Reyer in the company of laundresses (Notebook 28, pp 4 and 5) is the exception that proves the rule.
5. The small painting called 'The Laundress' in the Norton Simon collection shows a slightly open chemise.

CAT 16
1. *Davis*, pp 51–3.
2. Degas Notebook 30, p 65.
3. *Reed and Shapiro* no 36.
4. Theodore Reff, *Degas, the Artist's Mind*, p 171. Degas' remark was recorded by George Moore in *Impressions and Opinions*, London, 1891, p 308.

CAT 17
1. The second state of the print (*Reed and Shapiro*, p 81) appears to show foliage in the foreground, while the comparable etching (*Reed and Shapiro*, no 49) suggests a balcony.
2. See also the discussion of the analogous etching in *Boggs 1988*, pp 294–5.
3. See *Clark*, chapter 4.
4. *Herbert* p 83.

CAT 18
1. Pierre Cabanne was the first to publish a reference to a letter in which Degas reminded Boldini, prior to their trip to Spain in 1889, to bring some 'preservatifs'; see also *Boggs 1988*, p 296.
2. See *Clayson, Armstrong, Lipton 1980* and *Thomson 1988*.
3. Theodore Reff, *Degas, the Artist's Mind*, New York, 1976, p 180.
4. Degas Notebook 28, pp 26–35.
5. The illustrations for *La Famille Cardinal* are discussed in Reff, *op.cit.*, p 185 and *Boggs 1988*, pp 280–284.
6. See *Janis*.

CAT 19
1. Other plates with apparently identical dimensions are nos. 64, 75, 82, 83, 85, 86, 87 and 90 in *Janis*.
2. *Janis*, p xix.
3. A group of unspecified monotypes was exhibited in the 1877 Impressionist Exhibition.
4. *Clayson*.
5. Edmond de Goncourt, *La Fille Elisa*, Paris, 1877, p 49.

CAT 20
1. See *Boggs 1988*, p 205 and Anthea Callen's essay in this catalogue.
2. A general interest in caricature of many types is evident in Degas' notebooks.
3. Guy de Maupassant *A Woman's Life*, translated by H N P Sloman, Harmondsworth, 1972, p 427.

CAT 21
1. Ambroise Vollard, *Degas, An Intimate Portrait*, translated by Randolph T Weaver, New York, 1986, p 87; George Moore, 'Memories of Degas', *Burlington Magazine*, 1918.
2. Degas Notebook 30, p 208.

CAT 22
1. *Lipton 1986*, chapter 2.

CAT 23 & 24
1. Jonathan Mayne, 'Degas' ballet scene from Robert le Diable', *The Victoria and Albert Museum Bulletin*, October 1966, pp 148–56; and *Boggs 1988*, pp 173–4 and 269–70.
2. Degas Notebook 24, pp 7–21. For other studies, see *Boggs 1988*, pp 173–4 and 269–70.
3. Degas Notebook 24, pp 20 and 21.
4. Many of Degas' ballet scenes suggest the opera glasses' restricted angle of view, rather than a normal visual field; see *Kendall 1988*.

CAT 25
1. Henri Loyrette's research into the records of the Opèra has established the frequency of Degas' visits to performances; see the *Chronologies* in *Boggs 1988*. See also *Browse*.
2. See *Thomson 1988*.
3. *Shackleford*, pp 98–101.

CAT 26

1. Apart from the 'Little Dancer Aged Fourteen', the only clothed dancer sculpture (No. LII in *Rewald*) is effectively a dressed version of cat 26.
2. See *Millard*.
3. See *Thomson*, pp 108–9.

CAT 27

1. Walter Sickert, 'Degas', *Burlington Magazine*, November 1917, p 185.
2. e.g. L 701, 1066, 1208–9, 1304; and see Antoine Terrasse, *Degas et la Photographie*, Paris, 1983.
3. *Millard*.

WOMEN IN PRIVATE

1. See Roy McMullen, *Degas: His Life, Times and Work* and *Broude 1977*.
2. *Lipton 1980*.
3. Georges Jeanniot, *Souvenirs sur Degas*, October 1933.
4. Jeanne Raunay, 'Degas, Souvenirs anecdotiques', *La Revue de France*, March and April 1931; and *Michel*. The painting is 'Degas et son modèle' by Maurice Denis.
5. There are descriptions of Degas' studio in *Michel* and elsewhere.
6. *Michel*, p 634.

CAT 32

1. *Rewald* nos XXVII, LXVIII, LXXI, LXXII, LXIX, LXXIII.
2. *Rewald* no LXVIII.

CAT 33, 34 & 35

1. Related poses occur in L 1089 and 1090, but they are *toilette* scenes.
2. *Brettell*, p 161.
3. *Michel*, p 457.
4. George Moore, 'Memories of Degas', *Burlington Magazine*, February 1918, p 64.

CAT 36 & 37

1. Jeanne Fevre, *Mon Oncle Degas*, Geneva, 1949.
2. The development of this print is described in *Reed and Shapiro*, pp 124–40.
3. See *Boggs 1988*, nos 190 and 191.

CAT 38

1. L 787, 1285–92 and *Brame and Reff* no 142.

CAT 39

1. *Boggs 1988*, p 469.
2. See *Kendall 1988*.
3. See *Lipton 1980, Lipton 1986* and *Thomson 1988*.
4. The impoverished home of Maheu, the setting of Zola's *Germinal*, boasted a tub; see Emile Zola *Germinal*, translated by L W Tancock, Harmondsworth, 1954, p 118.

CAT 40

1. See Christopher Lloyd and Richard Thomson, *Impressionist Drawings*, London, 1986, p 47; and *Boggs 1988*, p 443–53.
2. Many of these reviews are cited in *Moffett*, pp 452–4 and *Thomson 1988*, pp 135–65.
3. Octave Mirbeau *La France*, 21 May 1886; cited in *Moffett*, p 453.
4. See *Broude 1977, Lipton 1986* and *Broude 1988*.
5. *Moffett*, pp 452–4; and Joris-Karl Huysmans *Certains*, Paris, 1889.
6. The fact that these figures were naked and surrounded by very few 'props' took away many of the standard indicators of class and status.

CAT 41

1. L 1117, 1119, 1120, 1127, 1128, 1231, 1233 and 1234.
2. See Denis Rouart, *Degas, à la recherche de sa technique*, Paris, 1945, p 44.
3. *Rewald* no LXXIII.
4. Emile Zola *Nana*, translated by G Holden, Harmondsworth, 1972, pp 222–3.
5. George Moore, 'Memories of Degas', Burlington Magazine, February 1918, p 65.
6. See *Thomson*, p 205.
7. L 1106.
8. This suggestion was first made by George Shackleford and Richard Thomson.

CAT 42 & 43

1. See *Millard, Thomson 1987, Thomson 1988*; and *Boggs 1988*, p 451.
2. *Moffett*, pp 453–4.

CAT 44

1. One of the few exceptions to this rule is also one of the most celebrated; the 'Nude Woman Having her Hair Combed', L 847.
2. Degas' nudes were not invariably seen as offensive; Mary Cassatt admired them (See *Boggs 1988*, p 443) and an anecdote told by Vollard suggests that they even failed to titillate (See *Lipton 1980*, p 65).

CAT 45

1. The problematic relationship between the facture and the image in such works is referred to in *Armstrong*.
2. Edmond de Goncourt, *La Fille Elisa*, Paris, 1877, p 137.

CAT 46

1. L 1028 and 1029.
2. The second, paler proof of the print was probably used as the basis of this pastel; see *Janis* nos 133 and 134.
3. There are some brothel monotypes that have been lightly tinted in pastel; see *Janis* nos 62, 63, 76, 84.
4. *Janis* nos 122, 124, 126 etc.

WORKS FREQUENTLY CITED IN THE TEXT

Carol M Armstrong, 'Edgar Degas and the Representation of the Female Body', in Susan Rubin Suleiman (ed), *The Female Body in Western Culture*, Cambridge, Mass, 1986.

Jean Sutherland Boggs, *Portraits By Degas*, Berkeley, 1962.

Jean Sutherland Boggs *et al*, *Degas*, Paris, Ottawa, New York, 1988.

Philippe Brame and Theodore Reff, *Degas et son oeuvre, a Supplement*, New York, 1984.

Richard R Brettell and Suzanne Folds McCullagh, *Degas in the Art Institute of Chicago*, Chicago, 1984.

Norma Broude, 'Degas's Misogyny', *Art Bulletin*, March 1977.

Norma Broude, 'Edgar Degas and French Feminism, ca 1880,' *Art Bulletin*, December 1988.

Timothy J Clark *The Painting of Modern Life*, London, 1984.

Hollis Clayson, 'Avant-Garde and Pompier Images of 19th Century French Prostitution', in S. Guilbaut *et al* (eds), *Modernism and Modernity*.

Marcel Guerin, (ed), *Degas Letters*, Oxford, 1974.

Robert L Herbert, *Impressionism; Art, Leisure and Parisian Society*, New Haven, 1988.

Thomas B Hess and Linda Nochlin (eds), *Woman as Sex Object*, New York, 1972.

Eugenia Parry Janis, *Degas Monotypes*, Cambridge, Mass, 1968.

Richard Kendall, *Degas 1834–1984*, Manchester, 1985.

Richard Kendall, *Degas By Himself*, London, 1987.

Richard Kendall, *Degas and the Contingency of Vision*, Burlington Magazine, March 1988.

Paul-André Lemoisne, *Degas et son oeuvre*, 4 vols, Paris, 1946–49.

Eunice Lipton, *Degas' Bathers: The Case for Realism*, Arts Magazine, May 1980.

Eunice Lipton, *Looking into Degas: Uneasy Images of Women and Modern Life*, Berkeley, 1986.

Charles Millard, *The Sculpture of Edgar Degas*, Princeton, 1976.

Charles Moffett, *The New Painting, Impressionism 1874–1886*, Geneva, 1986.

Linda Nochlin, 'Les Femmes, l'Art et le Pouvoir', *Les Cahiers du Musée National d'Art Moderne*, été 1988.

Ronald Pickvance, *Degas 1879*, Edinburgh, 1979.

Ronald Pickvance, *Edgar Degas*, Tokyo, 1988.

Griselda Pollock, *Vision and Difference*, London, 1988.

Sue Welsh Reed and Barbara Stern Shapiro, *Edgar Degas: the Painter as Printmaker*, Boston, 1984.

Theodore Reff, *Degas, the Artist's Mind*, New York, 1976.

Theodore Reff, *The Notebooks of Edgar Degas*, 2 vols, Oxford, 1976.

John Rewald, *Degas Sculpture*, London, 1957.

George Shackleford, *Degas, the Dancers*, Washington, 1984.

Richard Thomson, *The Private Degas*, London, 1987.

Richard Thomson, *Degas, the Nudes*, London, 1988.

Paul Valéry, 'Degas, Danse, Dessin', in *Collected Works*, translated by D Paul, vol 12, London, 1960.

ILLUSTRATION CREDITS

Reproduced with the permission of:

John Webb/Tate Gallery Publications,
London p 26, 27, 42, 52, 53, 55, 59, 63,
68, 69
Antonia Reeve Photography/National
Gallery of Scotland, Edinburgh p 14,
15, 62
John Mills (Photography) Ltd, The
Trustees of the National Museums and
Galleries on Merseyside (Walker Art
Gallery, Liverpool) p 41, (Lady Lever
Art Gallery) p 68
Prudence Cumming/Private collection
p 65
Alex Saunderson (Photography)/
Private collection p 47, 66
The Trustees of the British Museum,
London p 7, 19, 43, 66
The Trustees of the National Gallery,
London p 21, 28, 29, 31, 40, 49
The Burrell Collection, Glasgow
Museums and Art Galleries p 9, 32, 36,
37, 39, 49, 61
Fitzwilliam Museum, Cambridge p 51,
54, 67
The National Gallery of Ireland,
Dublin front cover, p 48
National Museum of Wales, Cardiff
p 58
Leicestershire Museums, Art Galleries
and Records Service p 55
Birmingham City Museum and Art
Gallery (The Archdale Collection) p 54
Private Collection, London p 19
Musée Picasso, Paris © Photo Réunion
des Musées Nationaux p 45, 46
Walsall Museums and Art Gallery: The
Garman-Ryan Collection p 25, 57
© Museum of Fine Arts, Boston p 60
Josefowitz Collection, p 33, 34, 40, 60
Wellcome Institute Library, London
p 11
Gilbert Mangin, Bibliothèque
Municipale Nancy p 12
Archives Nationales Paris p 13
© Sterling and Francine Clark Art
Institute, Williamstown, Massachusets
p 13
© Witt Library, Courtauld Institute of
Art, London p 15
The Los Angeles County Museum of
Art, Mr and Mrs William Preston
Harrison Collection p 19
Bibliothèque Nationale, Paris p 20
Kunsthaus Lempertz, Cologne p 20
Musée du Louvre/Cabinet de Dessins,
Paris p 21
Rouart Collection, Paris p 22
Royal Scottish Museum, Edinburgh
p 22
The Collection of Mr and Mrs Paul
Mellon, Upperville, Virginia p 10, 15
Board of Trustees of the Victoria and
Albert Museum p 50
Lombroso and Ferrero (Taken from
The Female Offender, London, 1985) p 12
Karlsruhe, Staatliche Kunsthalle p 19
Private Collection, New York p 18
Private Collection back cover, p 14, 20,
21, 35, 59
Musée du Louvre p 20, 21

ISBN 1-85437-025-1

Published by order of the Trustees for
the exhibition 'Degas Images of Women'
21 September – 31 December 1989

Copyright © 1989 The Tate Gallery
and the authors
All rights reserved

Prepared by Tate Gallery Liverpool,
Albert Dock, Liverpool, L3 4BB
Published by Tate Gallery Publications,
Tate Gallery, Millbank, London,
SW1P 4RG
Designed by Jeremy Greenwood
Filmset by August Filmsetting,
Haydock, St Helens
Colour origination by
Axis Photo Litho, Runcorn
Printed In Great Britain by
Cox Rockliff Limited, Liverpool